W I L L I A M
B A I L L E Y
BY MARK STRAND

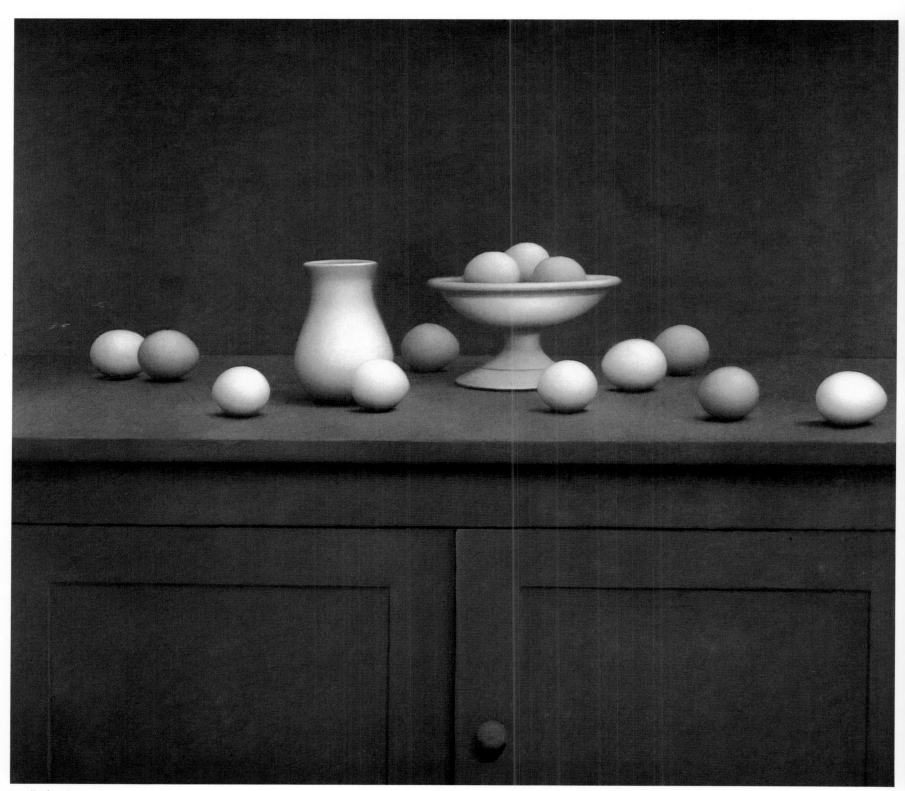

1. Still Life with Eggs, Bowl and Vase

WILLIAM BAILEY

BY MARK STRAND

HARRY N. ABRAMS, INC., PUBLISHERS, NEW YORK

Acknowledgments

I would like to thank my editor, Ruth Peltason, for her many valuable suggestions during the writing of this book and for her good humor and patience. I would also like to thank Jane Schoelkopf of the Robert Schoelkopf Gallery for her help in providing transparencies and information about the paintings.

M.S.

Editor: Ruth A. Peltason
Designer: Bob McKee

Library of Congress Cataloging-in-Publication Data
Strand, Mark, 1934–
 William Bailey.
 1. Bailey, William, 1930– —Appreciation.
2. Realism in art—United States. I. Bailey,
William, 1930– . II. Title.
N6537.B16S7 1987 759.13 87–973
ISBN 0–8109–0720–8
ISBN 0–8109–2360–2 (pbk.)

Times Mirror Books

Printed and bound in Japan

CONTENTS

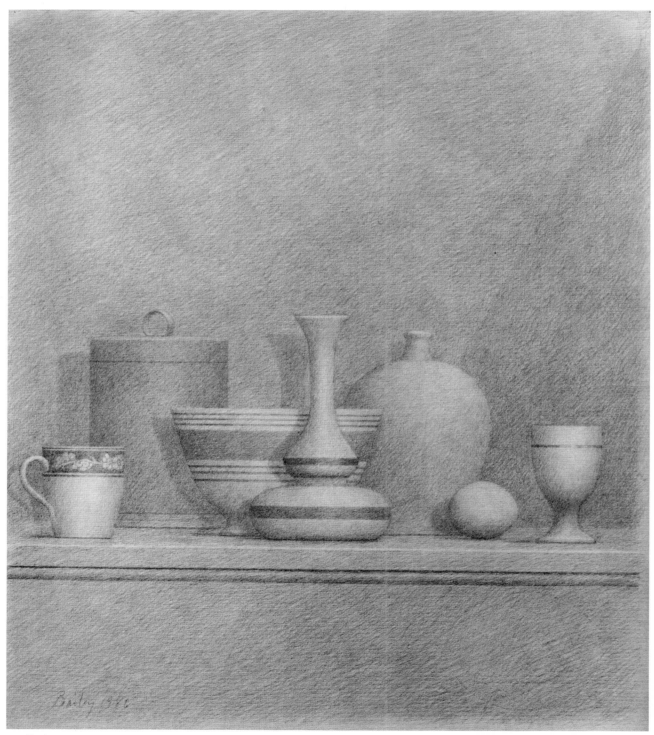

2. Still Life San Donato

I

There is a hiddenness about Bailey's still lifes that sets them apart from others. An air of refusal inhabits them, a calm, aristocratic denial of access. Has there ever been in the history of still-life painting anything quite like it? Still lifes have always ingratiated by practically holding their contents out to the viewer. Think of all the breads, fishes, hams, pipes, and flowers strewn through seventeenth-century Dutch painting. Think of the half-eaten fruit, the nutshells, and the pewter flagons on their sides in the paintings of Peter Claesz. Everything is surface—glitter, sheen, and spillage—nothing is held back. It is a world of appearances, not of ideas. The big meals, the leftovers, in spectacular disarray are as far removed from Bailey's work as still lifes can be. We do not know what is in Bailey's utensils. His pots, bowls, and cups are mute containers. They do not allude to actual life as the Dutch paintings do. They affect, in their remoteness, majestic self-interest, but discreetly, delicately enacted. Their reticence and clearness, or, I should say, absence of clutter, is reminiscent of the famous early Caravaggio still life of a basket of fruit that we encounter at eye level or the luminous Zurbarán painting of lemons, oranges, and a rose that have a stately existence on a table of the sort that appears in Bailey's work.

Bailey's affinities would appear to be southern European or Mediterranean. But there is a vast difference between reticence and secrecy. In neither the Caravaggio nor the Zurbarán do we feel so distant from the objects as we do in a Bailey. In Caravaggio, the fragile arrangement of

fruit is given a dignity not hitherto associated with still life, but it is not substantially transformed. In Bailey's work, the utensils sometimes strike one as monuments, tombs, or cenotaphs in their fixed, even final positions. Sometimes, the utensils seem to occupy not a tabletop so much as a stage. And they appear as characters playing out parts, as poet John Hollander has suggested, of eminence or subordination, but of the sort reminiscent of a family portrait.

If we look, say, at Goya's *The Family of Charles IV,* we can see a closer correspondence between it and Bailey's work than between Bailey's work and Goya's *Still Life with Salmon.* And this, despite the rank satirical character of Goya's portrait. It is the ceremonial aspect of Bailey's work that allows us to make the association between Bailey's utensils and members of Charles IV's family. The simple objects in Bailey's painting—picked up here and there, none of them expensive—are elevated, or reborn as John Hollander would say, as images in the frontal world of aristocratic portraiture. They seem to stare back at the viewer or else pose for him, offering a profile here, a three-quarter view there, always self-conscious in their manifestation as portrait figures. This runs counter to the history of still-life painting, where not only casualness has been portrayed, but accident as well.

Still, despite the clear view we get of Bailey's utensils, and despite their overwhelming assertion of presence, they are secretive, keeping a great deal to themselves, not the least of which is what they contain. It is as if they existed to remind us of the idea of containment and the painting as the arena of their containment. They contain and are contained. They hold in and hold together.

These objects keep appearing in different paintings by Bailey, always in new relationships with other objects. There is a kind of metaphysical primping in this, a turning this way and that before the glass of our vision. This adds an almost comic sweetness to the heavy austerity of the works, especially when a number of them are seen together. But what do the pots and bowls contain? The answer is "nothing." Nothing, that is, but their potential for figural, imagistic containment. They are abstractions, notions of shape, suggestions of volume, that hold the painting together—its tensions of space and figuration. They look like real objects but, of course, are not real. They have no life other than in the painting. They are not used to remind us of their utility in the real world. We don't see tabletops like those in Bailey's paintings, with the objects on them so painstakingly placed, nor do we stare very long from a single point of view at whatever we do find there. Instead, our world of objects is in constant flux and we are in constant motion. Our encounters are accidental, our arrangements provisional. Surely, this is what still-life painting has been telling us for hundreds of years. But in Bailey's work, each ordering forms a resistance to the representation of reality. What happens every day is not his concern— Bailey's concern is actually closer to that of the historical painting which represents what happened just once. And for Bailey, the "once" is what happens on the canvas—making each painting its own historic event, a terminal arrangement, a monument to itself.

Back to the notion of secrecy. What must be kept secret is the tentative and accidental character of each painting's origin, its uncertain route to completion. Any disclosure of difficul-

ty would violate Bailey's determination to classicize. The elevation of process—its turmoil and uncertainties—would be an indiscretion, an admission of vulnerability in conflict with the authority of the finished work. So the secrecy, the formal reticence of Bailey's work, is essential to its monumentality and, thus, its power. We receive Bailey's paintings only as finished works, breathtakingly concluded. Their existence, since they appear without origin, is magical. Their secret is that their materiality is an illusion; they don't exist except as representations, realizations of an idea.

II

Bailey's paintings differ, too, from Chardin's still lifes which are actually quite close in spirit to the Dutch still lifes, but more intimate, more involved with the comforting warmth and interiority of the home. In Bailey's work the home is absent. Are his still lifes like anyone's? Surely not like Morandi's, where objects try to establish a verticality, an uprightness, crowding always toward the center. Bailey's objects usually reaffirm the horizontality of the plane they sit on. The bowls, cups, and bottles in a Morandi seem, by their convergence, as if they were trying to establish stability instead of exemplify it. And the smallness of Morandi's paintings, their sketch-like tentativeness, contributes to an exceptionally modest pictorial character. In Bailey's work,

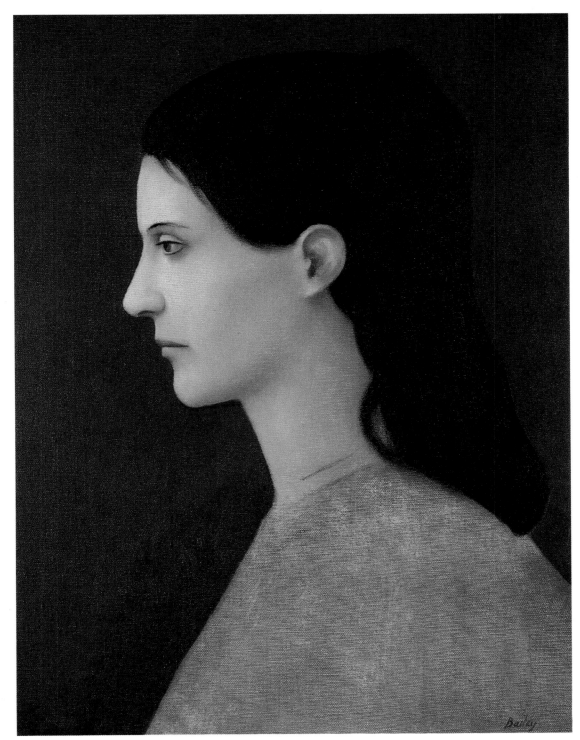

3. Italian Profile

because space is so ample, we do not experience the frailty of objects so much as their fixity, their having taken precisely the place where they should remain.

Nor do Bailey's still lifes have much to do with Cubist still lifes, despite their serenity which in some ways is like the serenity of a Juan Gris. For the most part, Bailey's paintings are the opposite of Cubist paintings, not because there are no pipes, glasses, guitars, etc., in Bailey's work, but because his arrangements are closed in an open or endless space. The space in Cubist still lifes has a kind of solidity, and the objects are fragmented, left open, and exist without enclosure or secrecy. They cling to the surface of the canvas as if to be discovered and known, to be reconstituted as things and to relinquish their lives as formal elements. They urge the issue of recognition and, hence, identity. It is up to us to make them whole again, to free them from the distortions of an unreasonable formalism. So, Cubist still lifes seem, with their claims on our attention, rather close to us, in fact, often they appear right under our noses or up against our eyes. By contrast, Bailey's still lifes seem far away—psychologically, in their self-sufficiency, but also spatially. In a catalogue for a recent show at the Schoelkopf Gallery in New York, painter and art critic Andrew Forge has said about Bailey's paintings: ''The more I look, the more it is brought home to me that these tremendous objects are not within my grasp. Everything, it seems, is slightly over life size, heavier, more substantial than things I know. I am at, or only fractionally above the plane of the table. The bottoms of the vessels run along that plane with a razor-sharp exactitude. But for all their palpability, they are far away.'' And Bailey has said

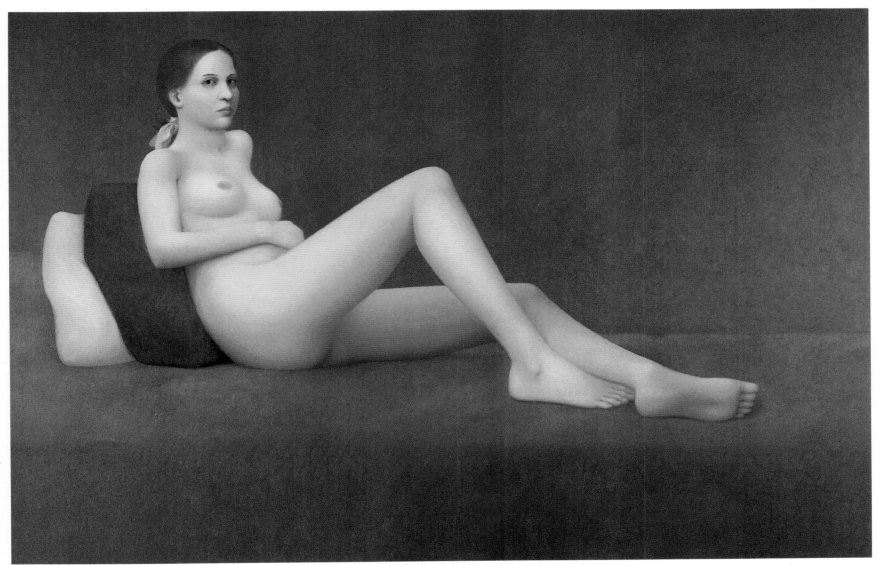

4. N

about his own paintings, "One visual paradox evident in my paintings which has nothing to do with realism is that the still-life objects seem to be painted from up close and yet the whole still life seems to be viewed from a distance."

III

Bailey's still lifes do seem far away, so far away at times that they appear in a remoteness we associate automatically with the out-of-doors. And yet, they are close enough to seem large. We read their details, easily recognize the reappearance of certain favored objects. Everything is in perfect focus. So perhaps we should consider the far away in Bailey as the far away brought near, and made observable—his paintings as close-ups of the unreachable. I once wrote about Bailey's still lifes and suggested that they had characteristics more commonly associated with landscape, and I went on to say that they were "like views of silent cities, Italian hill towns perhaps." I would modify my remarks now to read "silenced hill towns," since none of Bailey's paintings is extensive enough to suggest a city—a whole city. Being both close and far, Bailey's still lifes occupy, in the last analysis, a middle ground. In this, they are reminiscent of works by other painters, especially Piero della Francesca, in whose work the intimate or near is drawn out and given an existence that is only hinted at. That is, the intimate may not be seen, but its presence is felt. Piero's figures look off into space, lost in thought, and though it cannot be the

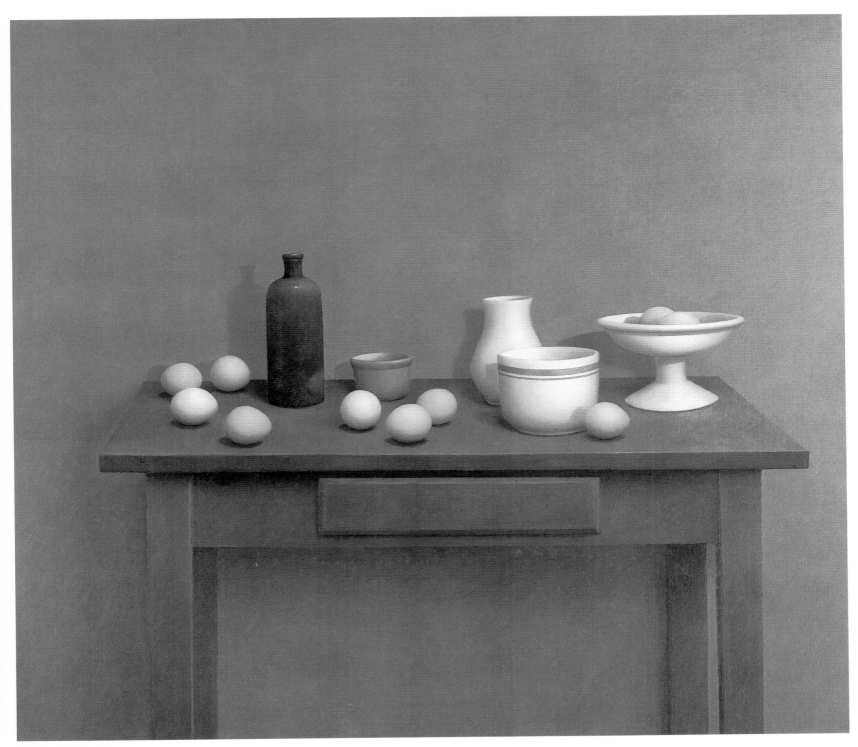

5. Table with Ochre Wall

precise nature of their thought that engages us, it is the world of thought, however abstract and invisible, that we respond to. The notion that Piero's people stand before us but are occupied elsewhere, puts the work, despite its solidity, its volumetric certainty, in the odd, even precarious, position of existing midway between the physical and the spiritual.

Another painter with whom Bailey has something in common is de Chirico. It may not be immediately apparent but de Chirico, in his early paintings, creates middle grounds that extend paradoxically into a distance where the present, or the temporally near, keeps asserting itself. His piazzas, with their loggias, their beflagged medieval towers, are the scenes of his dramatic reversals. The past, symbolized usually by classical sculpture, is close. The present, symbolized by the train, is far off. Caught between them are two figures with long shadows. The piazza is the symbolic terrain of the artist where his aesthetic choices are made. It can be presented comically, as it is in *The Uncertainty of the Poet,* where the artist's quandry is whether to choose art (the marble torso) or life (the bunch of bananas). Needless to say, while a decision is made, the present (the train in the background) passes in the distance. There is nothing so comic in Bailey's work, nor anything so overtly symbolic.

What Bailey does share with de Chirico, aside from the assertion of a middle ground, and what he shares with Piero as well, is the calm, almost predetermined way that his objects hold their place. The relationship between figure and ground is absolute, and so is the suggestion of silence. In de Chirico, silence is what separates us from the symbolic present that has been

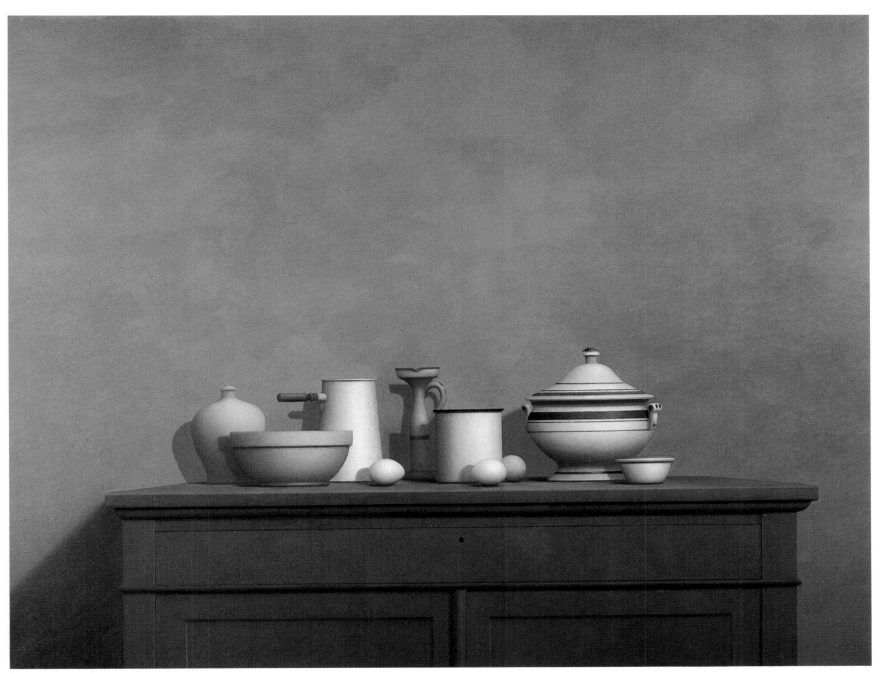

6. Migianella Still Life with Tureen

relegated to the background, far away on the other side of the piazza. A feeling one gets from looking at de Chirico is that the past is not merely what the foreground holds, but what one is looking through. In this way, his paintings are like memorials. They are silent. It is late. Everything is anchored in shadow. The passage of time has been accomplished. In Bailey, silence has to do with remoteness brought close, but also with the still, tomblike character of the paintings. Bailey's utensils hide their origins and deny any possibility that they might be real objects casually or randomly disposed on a tabletop. They are never chipped or cracked. They do not wear. For them, time does not pass. The utensils seem to exist without antecedent or future in an enormous, self-sustaining present. Instead of feeling that they have been ''caught,'' that their moment, the accident of their being or presence has been preserved, we have the sensation that we are seeing an arrangement that has always been and will continue to be long after we depart.

IV

Bailey's light is an invention. It is the light of the imagination—the neutral surround of an idea. It is without the temporal subtleties of exterior light—hinting at the time of day, the season of the year. Nor is it an interior light, one that illuminates a room, casting a comforting or critical glow on this or that object. It does not draw objects together, binding them into an image of domesticity. It is dispassionate, fixed, and conditioned entirely by the opacity of the

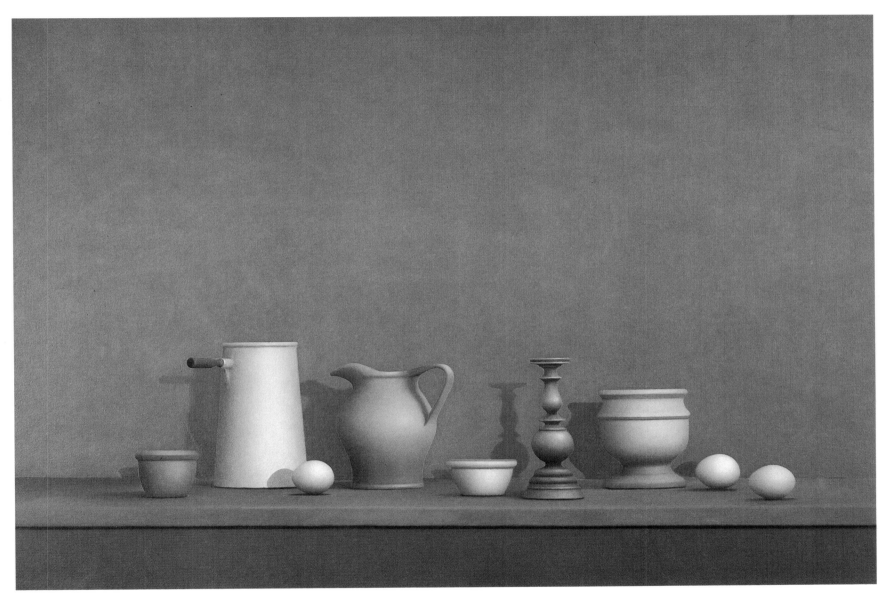

7. Migianella Still Life with Pitcher

walls and the table with its lifeless objects. There is nothing sentimental about Bailey's light; it is not trapped, it is not sent to liberate objects from darkness. It has no mortal dimension, and one cannot allegorize it any more than one can depict it successfully. As it describes, so it imprisons. In the way it highlights certain utensils, it positions them. Its orderly disposition of shadows fixes them. Bailey's light makes sure everything is permanently in place. When it strikes the crockery, it does so on each part nearest us, accentuating roundness, creating the flattering illusion that we, the viewers, may be the source of light, commissioned with the task of illuminating. (No matter where I stand in front of a Bailey, I have the illusion that I am directly before each individual object. The objects seem to be locating me, the viewer, instead of the other way around.) And yet the shadows cast by the crockery suggest that the light comes from just to the right of the viewer. The effect is that of a double lock, tightening security. This doubleness, this suggestion that the light of his paintings may have two sources, is so subtle that unless it is looked for it may not be perceived. It is as if two fictions become one, two points of view have the same story to tell.

Bailey's is a general light, but has particularizing properties. It is overall, but seems to illuminate the utensils individually. Again, perhaps it is actually two lights—one flooding the air, giving the pictorial space its tonal identity, the other striking the objects into radiant grandeur. In this, it has some of the quality of "luminist" light in which objects appear removed from their temporal existence, utterly fixed in an endless twilight. It is a light that clarifies and

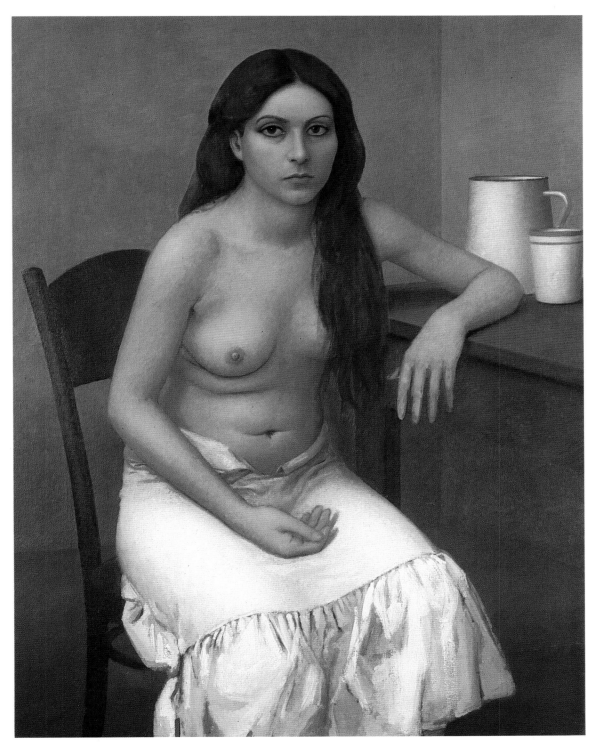

8. Girl in White Skirt

objectifies at the same time that it colors. When we look at Bailey's objects, we rarely believe we are looking through clear air, but rather through an air tinted by the dominant tone of the painting. The paintings radiate the light of a particular color, usually variations of terra-cotta or gray-green, and it is within (or against) such extreme conditions of color saturation that Bailey's pots and bowls achieve their luminousness and their structural authority.

Recently, Bailey has introduced corners or arches that not only complicate the spatial reading of his canvases, but extend the role that light plays. The interruption of a background that had asserted itself paradoxically as a section of an infinite interior has had, in some cases, the effect of localizing the still lifes, enforcing the notion that we are looking at pots and bowls in a real room. Bailey's corners and arches are also reminders of the earliest still lifes where a few randomly placed objects occupied one or several shelves of a niche. But only in some cases. Usually, we feel we are looking at buildings situated on a hilltop. This is especially the case in *Still Life Torre* (plate 16) where a strong diagonal of light comes in from the right, as if the sky had suddenly opened up. When looking at Bailey's paintings, sometimes it is as if the light—whatever its qualities—belonged only to the objects, and that the large areas of color, the back walls and table fronts, were the concessions, the benign reductions of darkness. We even feel, at times, that the objects, and not the light, are what oppose the dark, or that they are the light, its unexpected embodiment, and that this is the most extreme example of their power to contain.

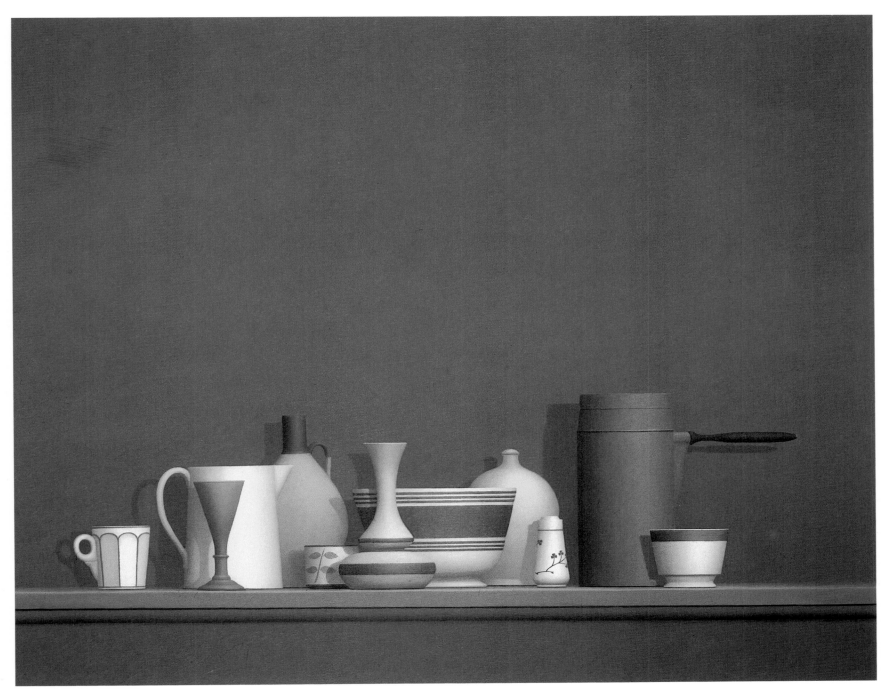

9. Manhattan Still Life

V

Several other modes of containment operate in Bailey's paintings. Their surface, described by Andrew Forge, "is a surface that is without accented brush marks. It could be called tight. But it is quite different from the tight surface of *trompe l'oeil.* It is not concerned with illusory textures. . . . His brushing is not transparent even though it is hardly visible. It does not pretend to be total illusion. We are always looking at a painting." It is a unified and unifying surface, one that is present as it erases itself—and cannot be considered apart from what it contains; it *is* what it contains. Again, this is one of the crucial differences between Bailey and Morandi. The nervous, approximate character of Morandi's objects is enacted not only by their crowding toward the center and seeming to lean on each other, but by the heaviness of their paint, the bravura brushwork, and the acknowledgment that no definition is final, that the boundaries of objects are provisional. The surface stillness of a Bailey, like the stillness of the utensils, helps to establish its air of mystery. Sometimes, it is as if we are looking at paintings not made with paint. Their substance seems, as Andrew Forge has said, "a universal substance, protean, invisible."

Bailey's pots and bowls—the ones he keeps in his studio and uses as models—change. Not only are their shapes altered to fit the requirements of a painted world, but their surfaces lose their relative roughness or smoothness, dullness or sheen. They become the abstract counters, the basic units of Bailey's paintings. And the endless variations of their deployment

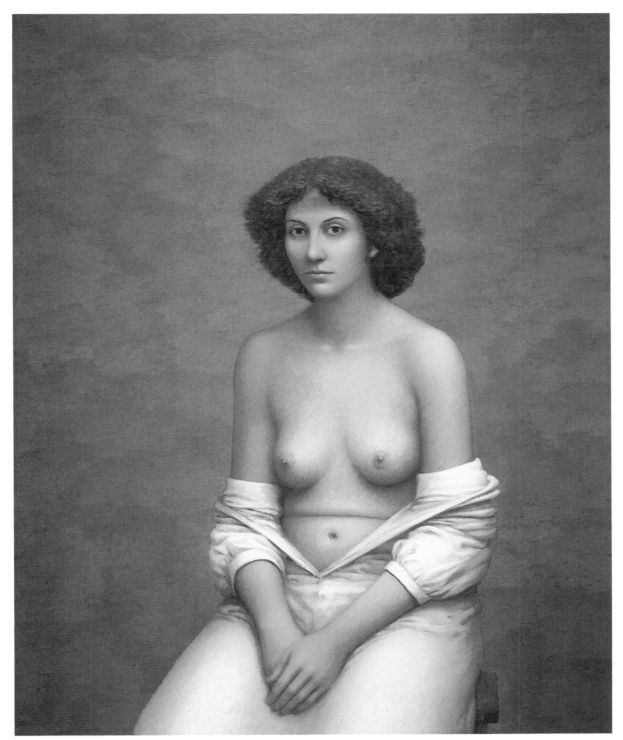

10. Portrait of S

become the radical terms of their formal identity. They disappear and reappear, always in roles that are being altered by the exigencies of particular paintings. The one thing they don't lose is the markings by which they are identified. Those blue or brown stripes of various widths, the tops and lipped lids, move like threads of different thicknesses, binding objects together not only within each painting but also from painting to painting, each stripe accenting the horizontal nature of the works or echoing how firmly each object is based.

VI

Questioned about the utensils that appear in his paintings, Bailey has said, ''The reason I select these objects is because they are the kinds of things that I've always had around me, the kinds of objects I like. They are the things I look at out of the corner of my eye, whether in the kitchen or some other place in the house, so they have been convenient in that way. Another reason is that I don't want objects that seem to require a particular context, either historical or social. A realist would insist upon a contemporary context and meaning, whereas for me they have a metaphorical existence.'' Bailey's cups, bowls, and pots have little inherited sentimental value, no identity that would detract from their modular character in the paintings. They have been glimpsed but never scrutinized, acknowledged but never, apparently, exploited. For Bailey, they have existed in passing, in those brief encounters a man has with household objects whose importance for him is not mediated by their utility. Bailey sees them solely in terms of their potential for

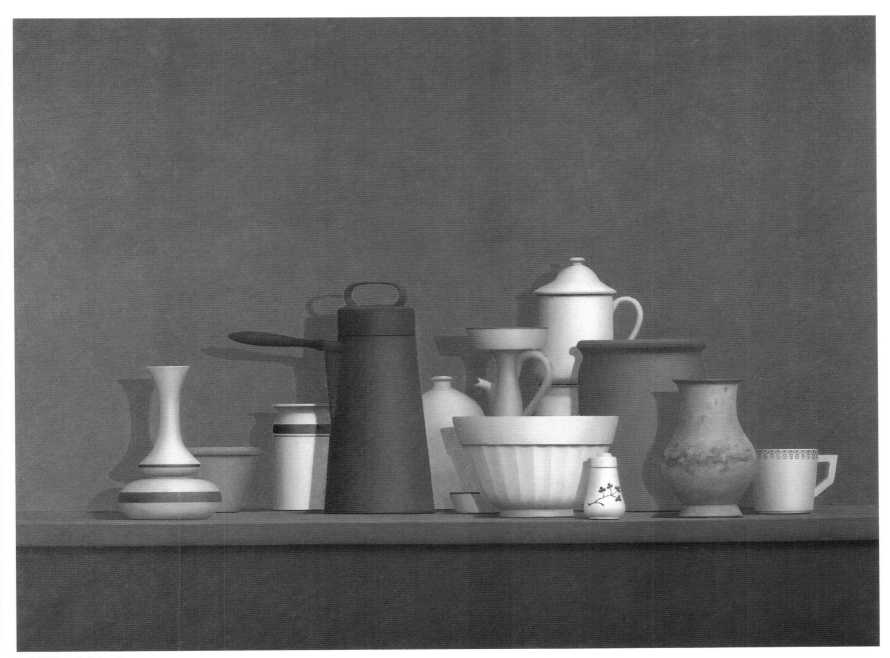

11. Still Life Città di Castello

paintings. Such an abstract, metaphorical existence is far removed from, say, the kitchen. They will be fixed before the viewer instead of appearing by chance in the casual and sometimes obscuring confines of a household. Chosen for their visual or harmonizing properties, Bailey's objects easily make the transition to a world of pictorial values. Left behind are indications that they might have been used as containers for food or drink, and their surfaces, whether metal, clay, or porcelain, have also been relinquished. They take on a new life, becoming part of a painted place, fitting into positions more permanent than their domestic lives would ever allow.

Shapes will change according to the needs of the painting. What is fat and short in one painting may be tall and slender in another. Compare the *Nogna* still life (plate 20) with the *Mercatale* still life (plate 13). The degree to which shared objects have been altered is very clear. The tin bowl with the blue and white enameling is lower and broader-based in the *Mercatale,* and the white cup is much larger, and so is the wooden eggcup and the old, long-necked, wide-based flower holder with the blue bands. In the *Nogna,* the old-fashioned New England potato masher is thinner and taller, and the bowl with the blue stripes is smaller and more delicate. Even the clay jug differs; it has a longer neck and a bigger handle in the *Mercatale,* but in the *Nogna,* its handle is two-toned.

Over the years Bailey's still lifes have changed. In the 1960s a few eggs appeared on a tabletop. Then a few utensils were added. Gradually, over the next fifteen years, as the utensils took over the eggs vanished, except for the occasional appearance of one, an affectionate reminder perhaps of humble beginnings. The early paintings made up mainly of eggs seem, when

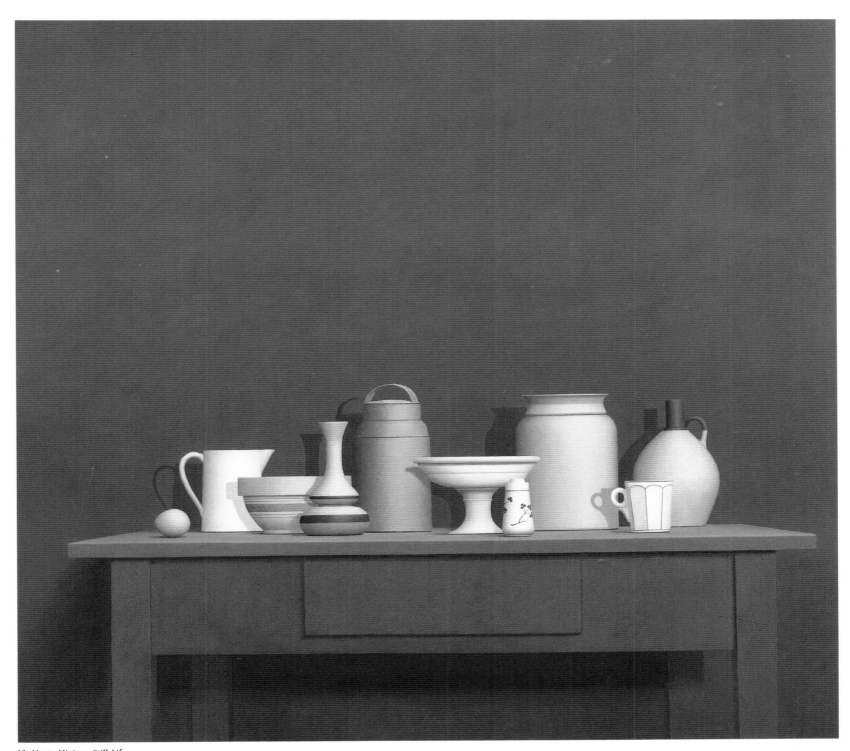

12. Monte Migiana Still Life

compared with recent paintings, casual in disposition. And the tabletops seem nowhere as ample as they do now. Increasingly they have become sites, and their objects have grown in size. Coffee pots are towers, bowls are colosseums, other containers are houses or forts, and between them shadowy piazzas, dreamlike passageways. And then they are nothing of the kind, but themselves, as they were, parts of an elaborately orchestrated picture that is much more powerful and assertive than its individual pieces. What began with a few eggs on a table has become an image of immense inaction, an apparition of fixity and quietude.

Even the titles of the paintings have changed; no longer do they single out one of the utensils—a white pitcher, a coffee pot, a compote—for special mention, forcing the viewer into a literal reading, just in case he had other ideas. Now they are named for cities, piazzas, or villas urging the viewer away from literalness, into a realm of possible resemblance, distant likenesses—that middle ground of associations that concludes in abstraction. Bailey has said, "All of my titles are more or less associations." The colors of a painting he is working on will remind him of a place or town, so he will name it for Monterchi ("It is all greenish-bluish grays and pinks and ochers, unlike Umbrian towns, which are for the most part ochers and siennas"), or Città di Castello or Fratta. Sometimes the association is not so tangible, but will depend solely on the "feel" of a place and the "air" of a painting. The important thing is that the viewer is invited to attach what he sees to what he is told to imagine. The near and the far are joined. The painting, just as I spoke of it before, is the middle ground. The transforming, ordering bridge between small and large, inside and outside, real and ideal.

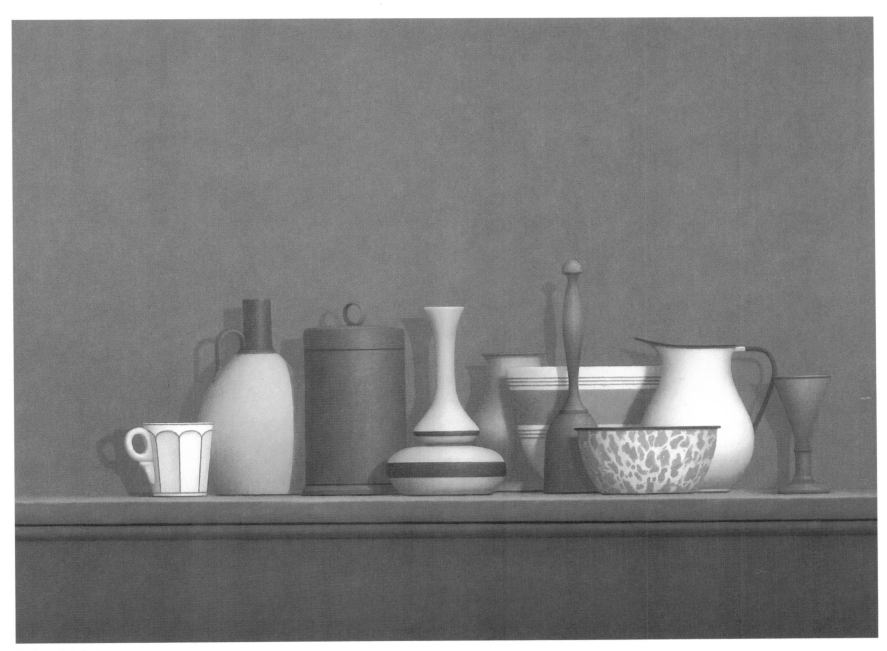

13. Mercatale Still Life

VII

I have heard it said that Bailey's still lifes are all the same; that he uses the same bowls and cups again and again, and never deviates in his presentation of objects from eye-level frontality. It is also said that his range of colors is small and dominated by ochers and siennas. Such criticism comes from those who not only fail to see the changes in Bailey's work, but fail to realize that change is at the heart of his enterprise.

In our culture, we tend to acknowledge only glaring changes, so it is no surprise that some of us would be blind to Bailey's subtle revisions. Change has become an end in itself. It relieves us of the responsibility of coming to terms with values that are more or less enduring. And yet, our appetite for change is never satisfied because our ability to adjust has kept pace with even the most extreme novelty. Anticipation quickly becomes disappointment, which in turn becomes anticipation. Only the next "new thing" can assuage the dullness of the last "new thing." It is the same in the world of art as it is in the world of fashion. The so-called revolutions in each, though attempting to wake us from our cultural drowse, give us little occasion for really waking up. To recognize, and then to participate in the changes offered by Bailey's work, one first must believe in its vision of permanence, feel its weight, be moved by its clarity; in other words, be utterly convinced by its capacity to order.

Every painting is an answer to randomness, a metaphysical solution—each object has found its proper place in the scheme of things. And the arrangement, inasmuch as it is an ideal

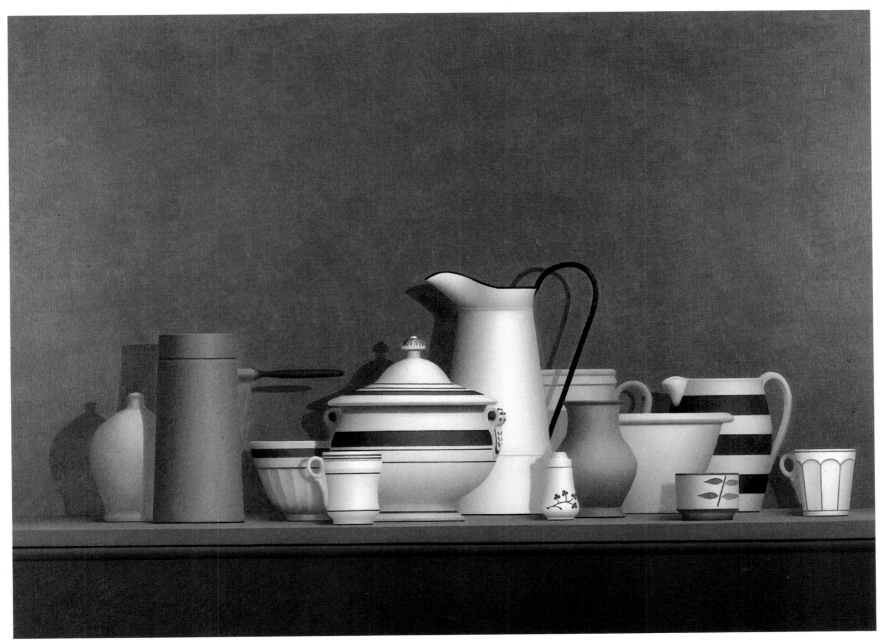

14. Still Life Monterchi

order, inspires belief. So that when a number of Bailey's still lifes are seen at the same time, we are forced to experience the provisional nature of even the most extreme order. The painting, instead of being conclusive, becomes a revision, a judgment on the previous painting's power to enchant and to subdue anxiety. Bailey's seemingly reductive world of pots and bowls on a table becomes complex. His objects are as basic as colors in their capacity to recombine into new figurational orders. In its studied reordering of ideal groupings, Bailey's work is anything but repetitious. Objects keep reappearing, sometimes with their size or shape slightly altered, sometimes with the stations they occupy changed, and as a result their positions are diminished or aggrandized. Each change, we feel, is a *new* final chapter in the life of the objects. To miss these permutations in Bailey's work is to resist what amounts to a critique of what passes for change in our culture.

VIII

Early in his career, Bailey painted figures to the exclusion of everything else. Now, when he has a show, there may be one or, perhaps two, figure paintings but never more, even though there are always several being worked on in his studio. Perhaps they have become more difficult to do, perhaps Bailey is uncertain of what he wants them to be.

The demands of the figure differ from those of the still lifes. Bowls and pots can easily be manipulated, moved around, lengthened or shortened, made rounder or slimmer, but a figure,

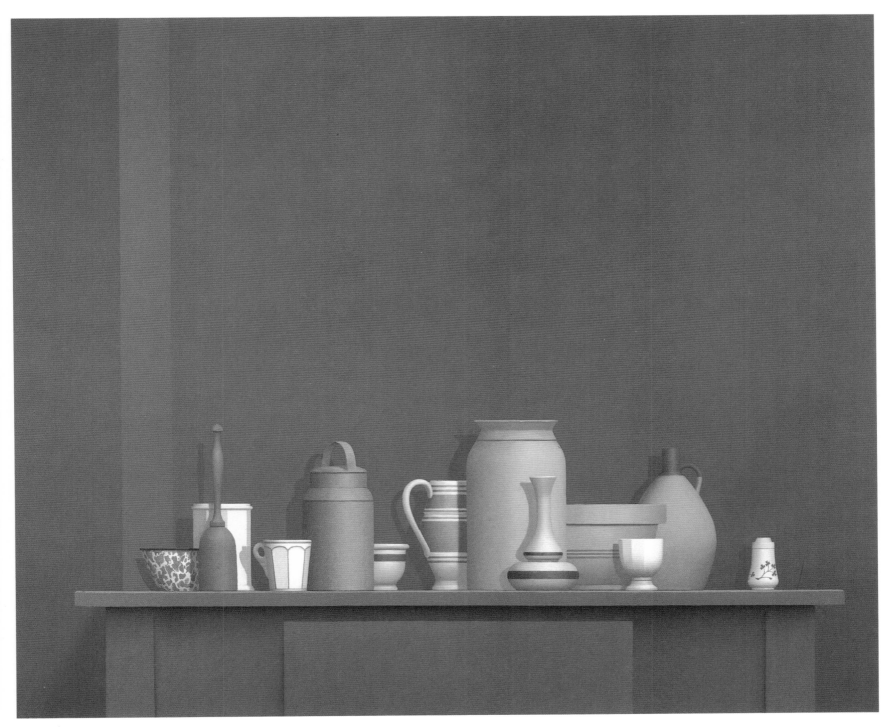

15. Still Life Pisa

treated in a like manner, runs the risk of becoming a grotesque. In addition to the formal limitations a figure imposes if it is to remain recognizable, there are psychological considerations. The figure, after all, may be modeled on a living person who has not only posed naked before the painter, but has allowed him to represent her as he wishes. It may be based upon the memory of someone who once posed for the painter and the memory may be mediated by any number of drawings that either diminish or restore the presence of the model. By the same token, there may have been no single source for the painting—the figure may be, instead, a composite of many models, some of them figures that exist in the paintings of others. Some of this complexity is expressed in the following statement made by Bailey in *Art of the Real:*

> I have an anxiety about the figure paintings, and I find that this influences the work. It is hard to describe, but the anxiety I am talking about has to do with the nature of my relationship to the imagined figure and place. The figure takes on a reality for me and embodies many contradictions. I am forced to make changes, trying to get something right—but I can never say exactly what that thing is that will make the painting seem right to me.

Because Bailey's concerns rest primarily with the imagined figure, the model, actual or remembered, will not have that much to do with the outcome of the painting. Bailey will use what he needs from her, which may or may not coincide with what she has to give. That is, he may represent her in ways that might seem uncharacteristic or alien to her, or to her creator if she is the creation of another painter. The only way to ignore such a discrepancy is to pretend

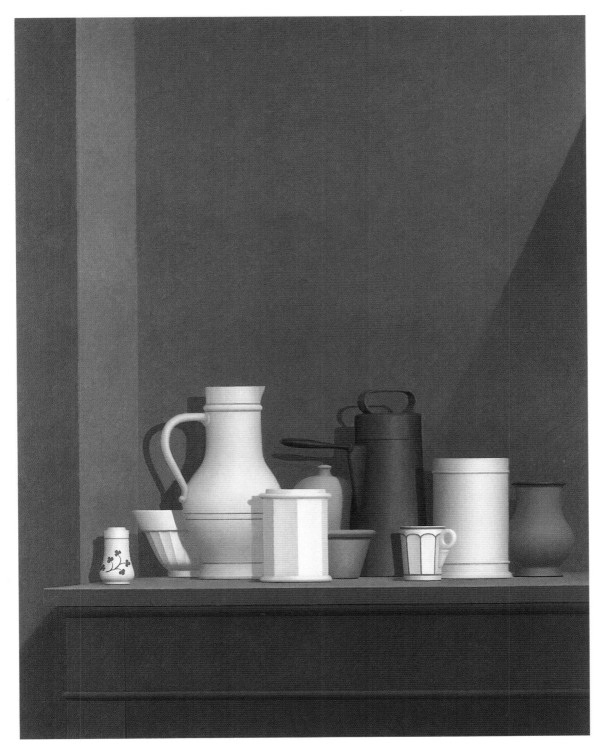

16. Still Life Torre

that the model does not exist, which for Bailey is a possibility because of his absorption in the imagined figure.

Not the least of the many contradictions embodied by the figure is that it contains elements of both artist and model. The imagined figure might be a projection of the artist, and embody his turning away from what could have been the actual source of his painting. His projection of himself, a transference that is unconscious, might find its way into the expression of the imagined figure's face, or even, at times, into her posture. It may be an elaborate way to paint oneself into a painting; it may be a means of artistic survival, especially if the model is to be found in the work of an illustrious precursor.

Perhaps the reason why Bailey can never say what will make the painting seem right to him is that he cannot be certain of what he is painting. The figures declare themselves as female nudes, but seem to question his or the viewer's authority to claim them as such. In some strange way they seem to be talking back to their maker. And this is not the first time it has happened in the history of art. A great many nudes, those with their eyes open and looking straight out— seem to have a tense, questioning relationship with whoever is looking at them.

IX

In Bailey's painting, *N* (plate 4), a young woman with very long legs is propped up by some pillows on a dullish green counterpane. We see her face and torso at a three-quarter angle. She appears wary but relaxed. Her gaze is detached, but her pose announces her availability. She is

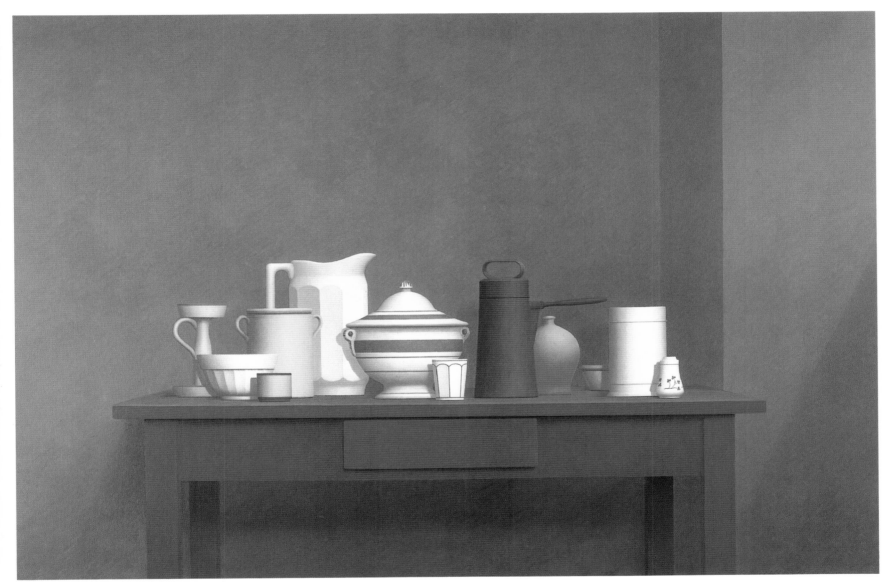

17. Still Life Genoa

sexy but not voluptuous. She has, despite the knowing look in her eyes, a sort of virginal, unblemished beauty. Her flesh, it would seem, like Bailey's utensils, has never been soiled by wear. Although her torso is turned toward us instead of away, she resembles, in her mixture of attitudes, Ingres's *Grande Odalisque* who also stares at the viewer, with a look that dismisses as it invites. Her back is to us not exactly out of modesty, but more likely because it offers the greatest extent of caressable flesh that is soft and warm, yet cold and marmoreal.

How much more graceful she is than David's nude study for Mme Récamier done fourteen years earlier in 1800! David's nude is much less idealized, much less exotic, though she assumes the same pose. (Oddly enough, the left foot of *N,* the odalisque, and David's nude, is pretty much the same foot, except that David's is the only one that appears to have been walked on.) I can't speculate on how the *Grande Odalisque* came to be except that it must owe as much to David's study as to any live model. I suspect the same is true of *N*—that it is a mixture of observations from the *Grande Odalisque,* a living model, and Bailey's own engagement of each. It is a composite, an invention, and, in its formal rendering of erotic possibility and denial, an abstraction. Such long legs could not belong to a real person, but they do, like the odalisque's back, offer more of a good thing than could ever be used, and help stabilize and center the body (see the position of the small triangle between the legs over an exaggeratedly horizontal plane). A model may have been used initially, but the painting as it was finished came to be more and more a work of formal accommodation and, hence, imagination. Bailey replaced the model with his version of the Ingres, and the combined presence of the two constitutes a wariness that is both

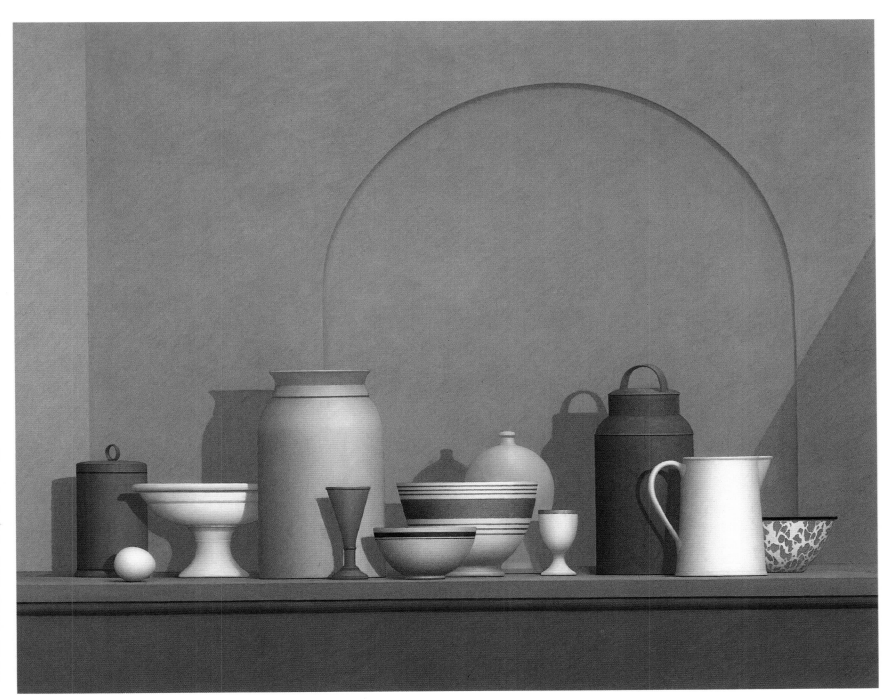

18. Still Life Hotel Raphael

accusatory yet oddly forgiving. A neoclassical mixture of remoteness and sensuality has been accomplished in a figure that, despite the absence of clothing and perhaps because of its hairstyle, manages to be wholly contemporary.

Almost all Bailey's figure paintings bear certain resemblances to the works of others. One of the strangest of these is *L* (plate 19) who looks like she wandered into a Bailey out of a Balthus painting. Not a particular Balthus, however, but a composite. She has traces of the pubescent *Nude in Profile* although she is slimmer, and there is even something of *Nude in Front of a Mantel,* a calm self-absorption. Most elusively, she is reminiscent of the demonic child in *The Room.* She has an adult face, but her young girl's body is paradoxically adorned with breasts and pubic hair. These signs of womanhood seem like the excessive issue of her mental precocity. The sudden evidence of her maturity, of her becoming a vessel with the capacity to contain another life, is underscored by the appearance of one of Bailey's cups from his still lifes on the table beside her. The isolated cup is a sign, and for some reason an unhappy one, that her life as a woman has begun. The peculiarity of this painting gives it a remoteness from everyday life that would disqualify it as realistic, but, on the other hand, it does symbolize something that is an everyday occurrence. What it also does—and here is where Bailey's anxiety about the imagined figure is especially forceful—is to release the arrested maturation of Balthus's pubescent girls, to bring them into womanhood, to complete them, without allowing them to relinquish their past entirely. *L* is both an homage to Balthus and an attempt to move beyond him.

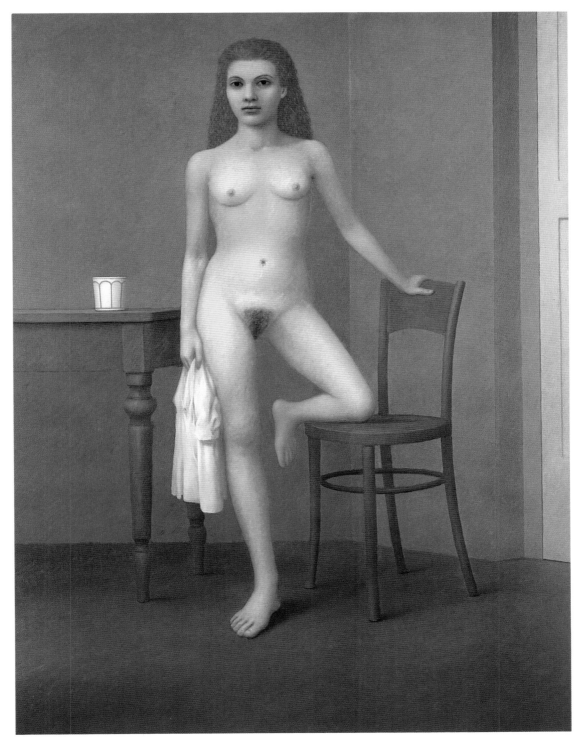

19. L

X

The least odd of Bailey's figure paintings is *Portrait of S* (plate 10). It has the ease and intimacy of Bailey's drawings. It is as though none of the anxiety he brings to figure painting in general were involved in the painting of *S.* There is no uncertainty here, no turning away from what we experience as the actual presence of *S.* If much of it was painted away from the model, as Bailey has admitted, we would not know it.

Nothing about *S* calls into question Bailey's authority, or the viewer's right to appreciate her. Nothing about her pose or demeanor manifests a resistance to, or impatience with, her objecthood. Her dress is peeled down to her waist, exposing her breasts and a fold of flesh across her belly. It traps her arms but she seems not to care. Her hands rest on her lap. Her bondage is not her concern. In *Art of the Real,* Bailey said about *Portrait of S:*

> I worked on the painting over a period of two years. It was very hard getting it working together, that is, to get arms to go through the sleeves and to keep that white thing that she's wearing—which I wanted to make into a kind of nightdress—from being mere drapery. And there was a problem with trying to keep something that I liked about the luminosity of the breasts in relation to the face, in relation to the lap. And then qualities that you just can't talk about—the particular presence of that person.

Bailey is attentive—as he always is—to the imagined figure and the formal issues raised by the disposition of a complex figure in space, but he seems, in the case of *S,* especially responsive to

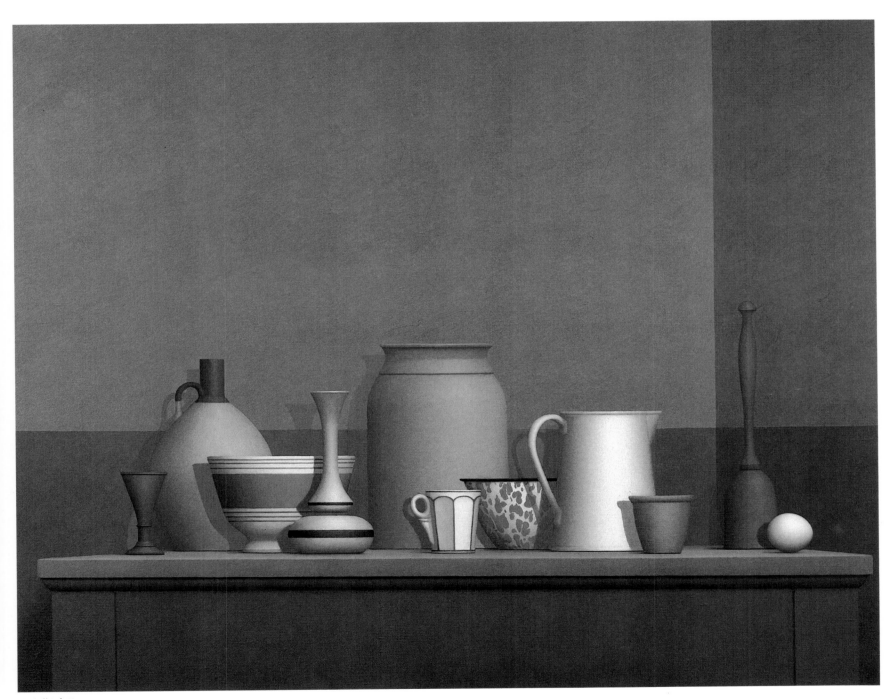

20. Still Life Nogna

her "particular presence." It is a different kind of attention that is being paid. It is related to the delicate, detailed engagement of his drawings with the female figure, but less investigatory, less a form of interrogation.

Bailey draws compulsively, stockpiling discoveries for use in his paintings. In this way all his drawings are preparatory to his paintings, but they are more than just sketches. They have a terminal character of their own, an edge, a firmness, despite the virtual absence of compositional concerns. Their figures assume a variety of poses and are endlessly informative. But they are not the shorthand that most drawings done in direct preparation for a painting are. They do not attempt to capture a gesture, a fleeting insight. Rather, they concern themselves with nuance, the barely perceptible shifts of shadow on skin, the smooth gradations of flesh as it hides the skeleton. They have a lightness, a touch, that is able to convert any pose, even an awkward one, into an expression of grace. In this they are reminiscent of the drawings of Ingres. And like Ingres's drawings, they indicate a perfect preparedness to paint the figure. "Drawing," said Ingres, "is seven-eighths of what makes up painting." He also said, "Drawing includes everything except color." I don't know if Bailey would agree, despite his admiration for Ingres. In the case of S, however, he might.

It is through drawing, the persistent application of seeing, that the individual character of the subject is revealed. It is a form of study, and the success of S is the result of a great deal of diligence on Bailey's part. Although her presence and the unifying elements of her pose—the stacking of triangular shapes, from crossed hands at the bottom to chin at the top—are present-

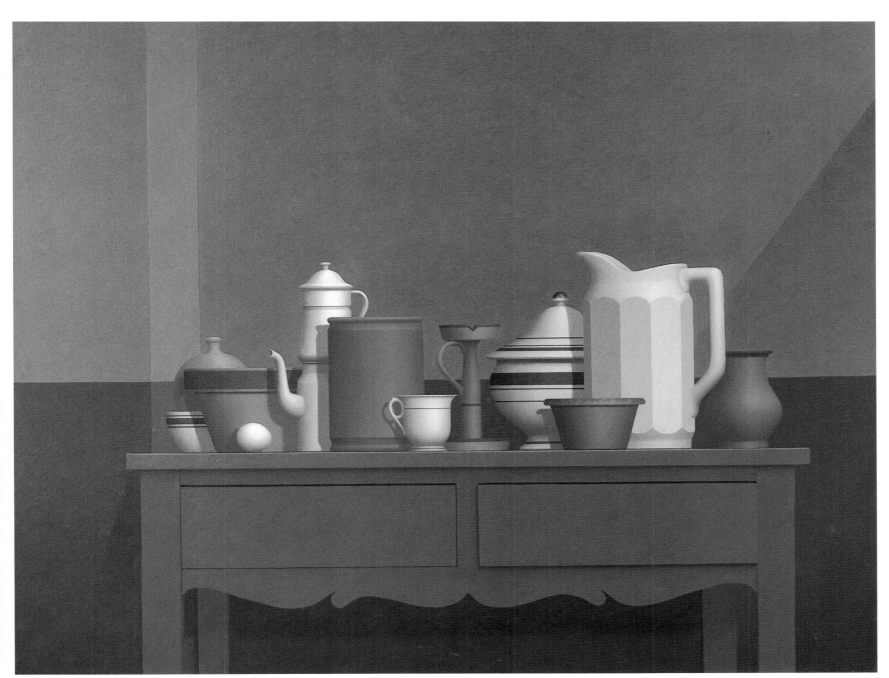

21. Still Life Noto

ed with utmost clarity, there is something else about her that is compelling. It is the subtle, almost secret way that *S* alludes to Raphael's portrait *La Muta,* which hangs in the Ducal Palace at Urbino, and which Bailey must have looked at many times. They have the same nose, the same lips, their eyebrows have the same arch, although *S*'s are darker, their chins are alike, and so are their necks although *La Muta*'s may be a touch longer. Still, *S* manages not to look like *La Muta.* Her face is a different shape, her hair is a dense cloud of curls instead of straight, her shoulders are square, not rounded, her bearing is casual instead of aristocratic. And *S* is half-undressed whereas *La Muta* is fully clothed. *S*'s breasts are bare, *La Muta*'s are hidden. But beyond the physiognomic and physical likenesses and differences between the subjects, they give off a similar serenity, an alertness glazed over by the dullness of posing, a dignity, a straightforwardness.

XI

Because Bailey paints recognizable objects, he is generally thought to be a Realist. But painting recognizable objects is not enough to make one a Realist. It is the use to which they are put that determines what the true subject of the painting is and whether the painter is a Realist.

At its most benign, Realism's subjects are derived from daily life, their theme is men and women in the world of their making. At its most reductive and doctrinaire—as socialist realism—its subjects are the triumph or martyrdom of the working man, and the class struggle,

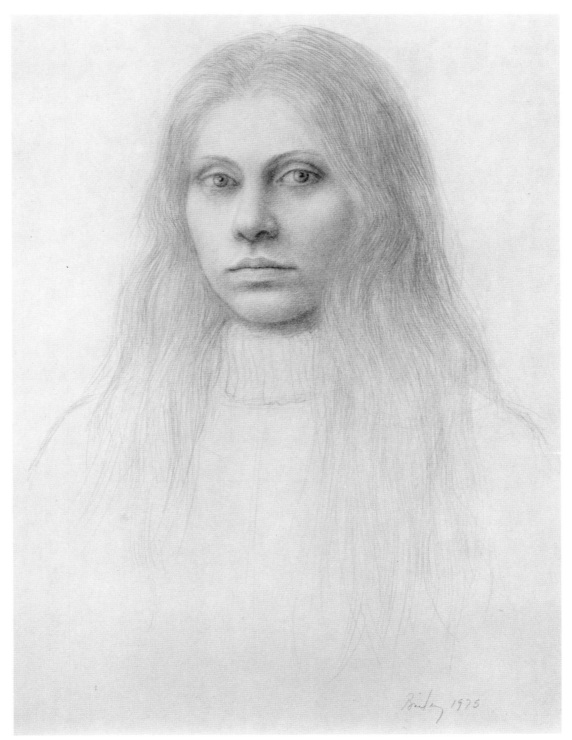

Buiten 1975

22. Head

with the forces of good and the forces of evil easily identifiable. Realism grew out of genre painting whose everyday subject matter, because it was not historically memorable, was thought unimportant. In the nineteenth century, genre painting became Realism. It was then that what happened every day became not only important but what effected history. For the most part, Realism was no more than genre painting with a social conscience.

Recent revivals of Realism, with their concern for significant content and their well-meant pleas for a better world, seem increasingly like exercises in nostalgia. The simplifications and banalities of Realism's reappearances are always delivered with the self-righteousness of those who have found the "better way," which it turns out, is always the literal way. None of this is for Bailey, whose work exists in a context that is primarily esthetic, whose reality is ideational, and whose painting world is the fastidiously ordered approximation of an invisible one. He is a Platonist. His reality transcends our common experience, it has no visible moment of inception. His paintings are grandiose and hieratic, self-contained, and secretive. Nothing in them suggests the transitory. There are no hourglasses, wilted flowers, or skulls to tell us our time will soon be up. There is nothing narrative in them. They present us with a version of timelessness, of things disposed to perfection.

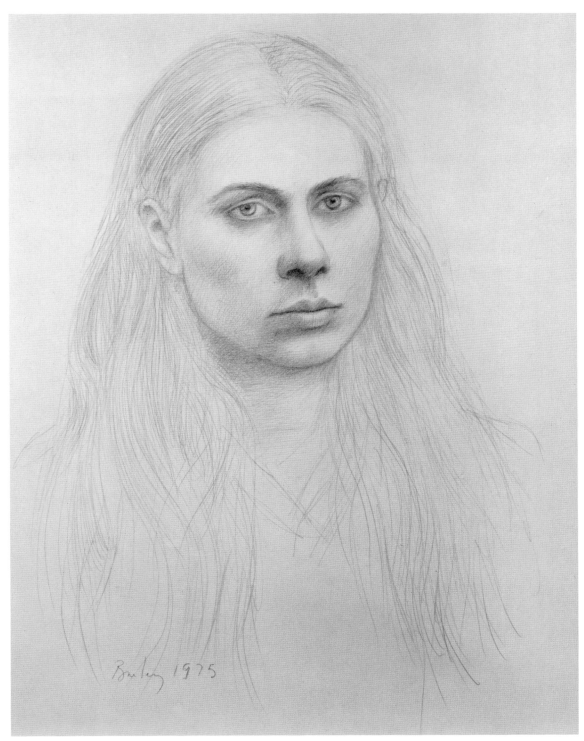

23. Portrait of Dee

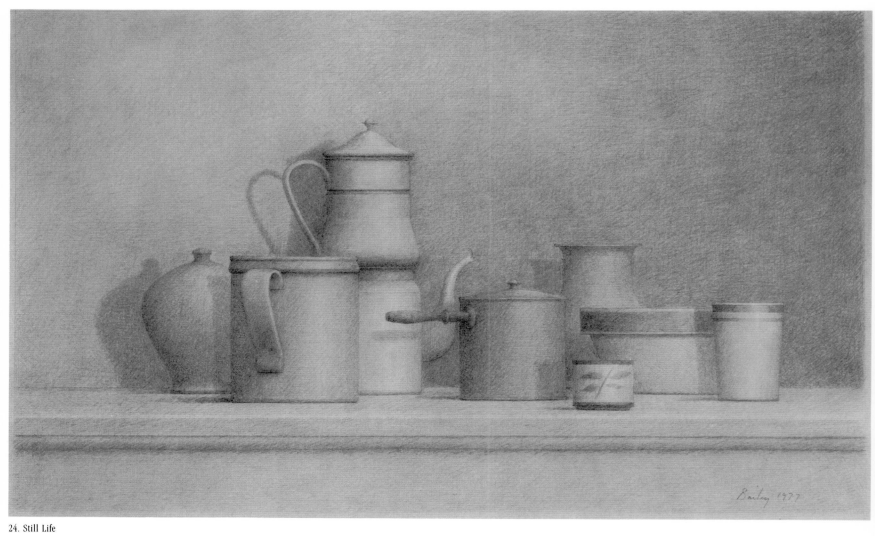

24. Still Life

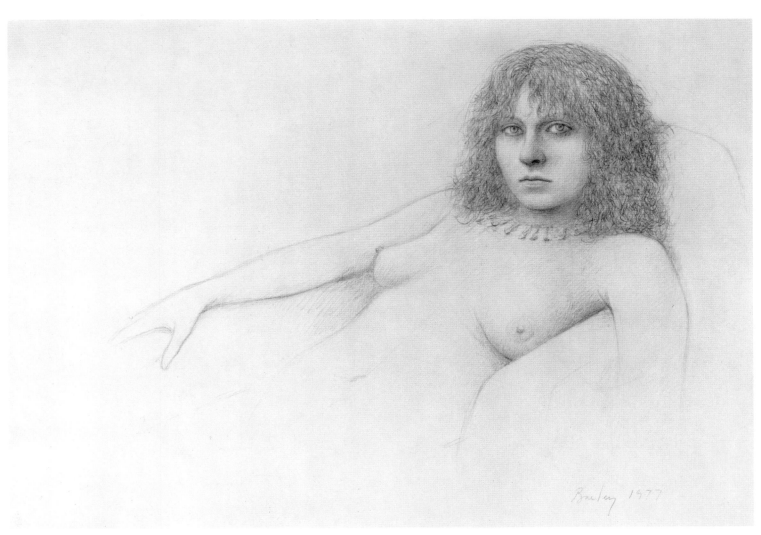

25. Girl with Necklace

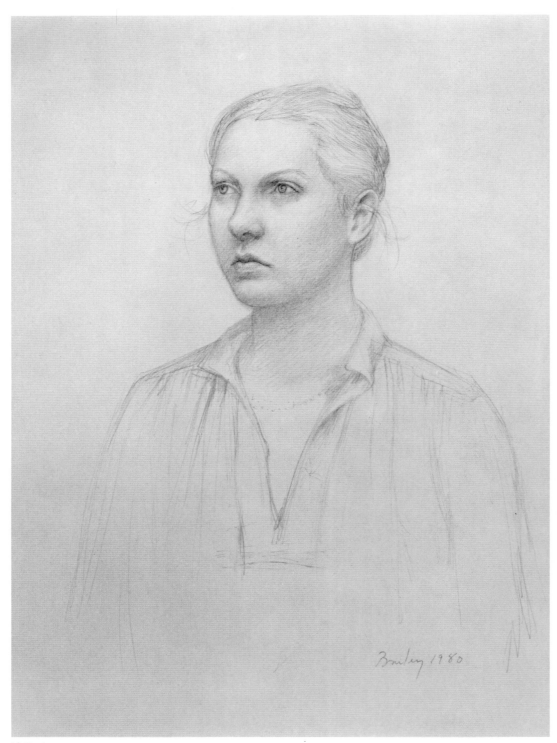

26. Head

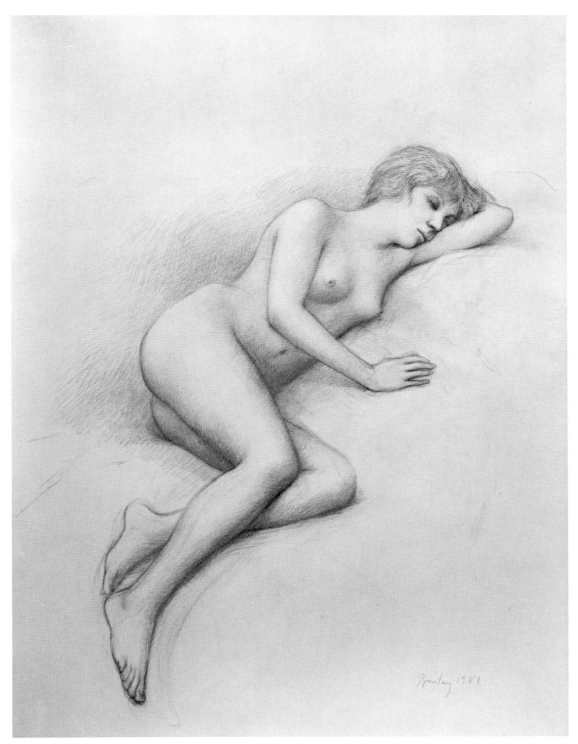

27. Reclining Figure

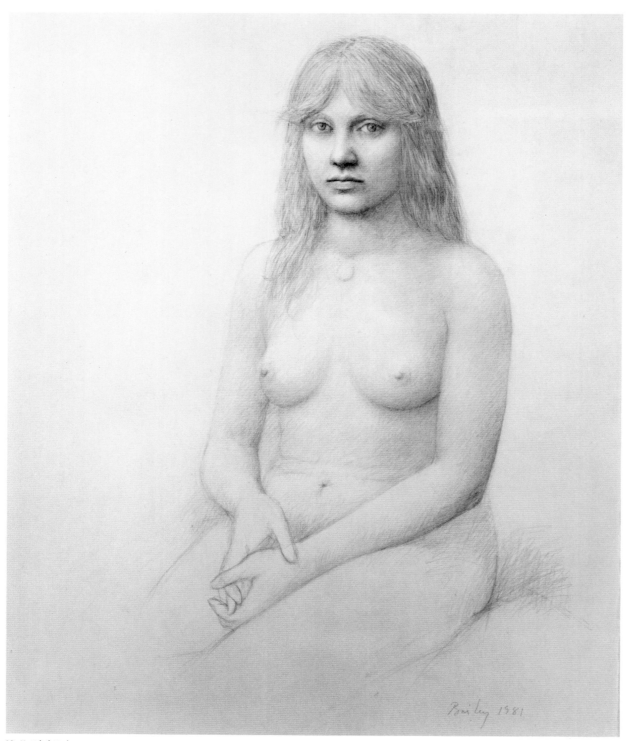

28. Untitled Nude

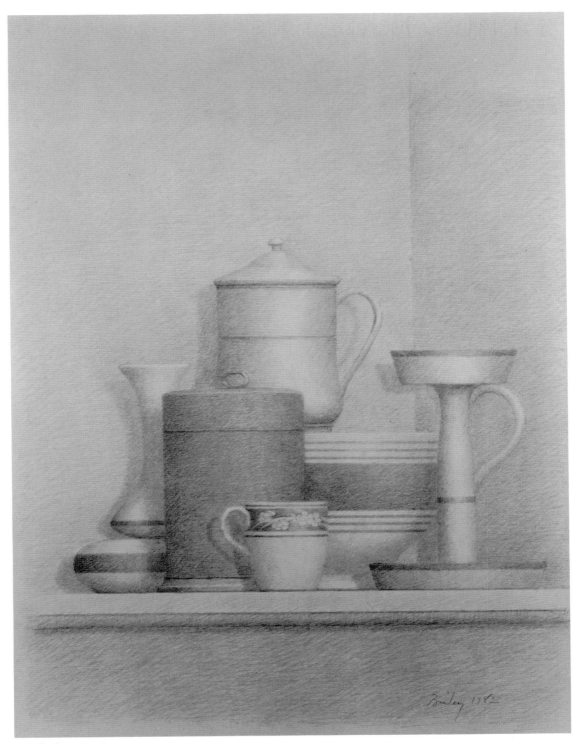

29. Still Life Piazza Bologna

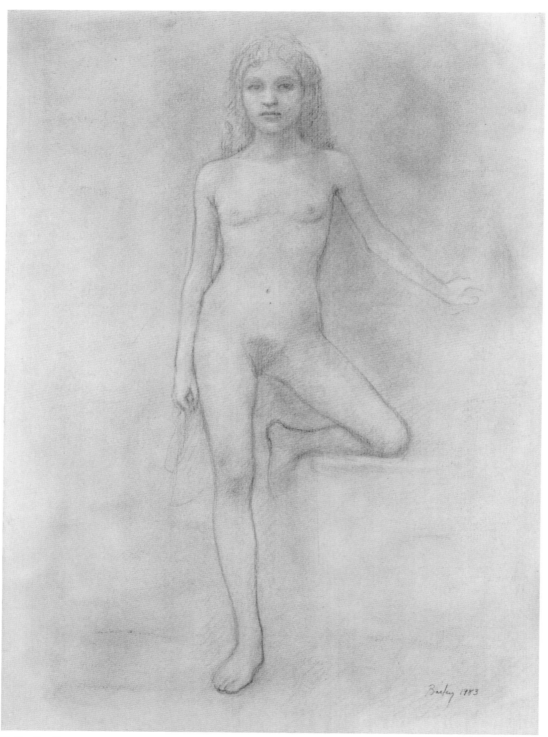

30. Standing Figure

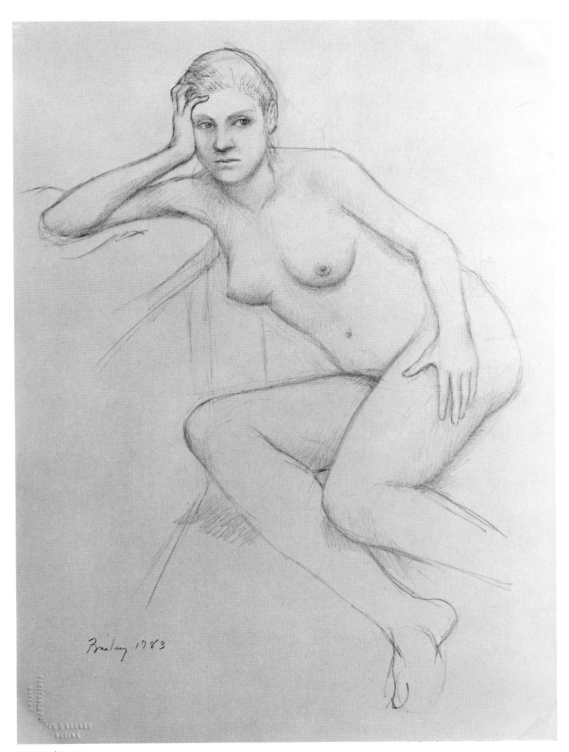

31. Seated Figure

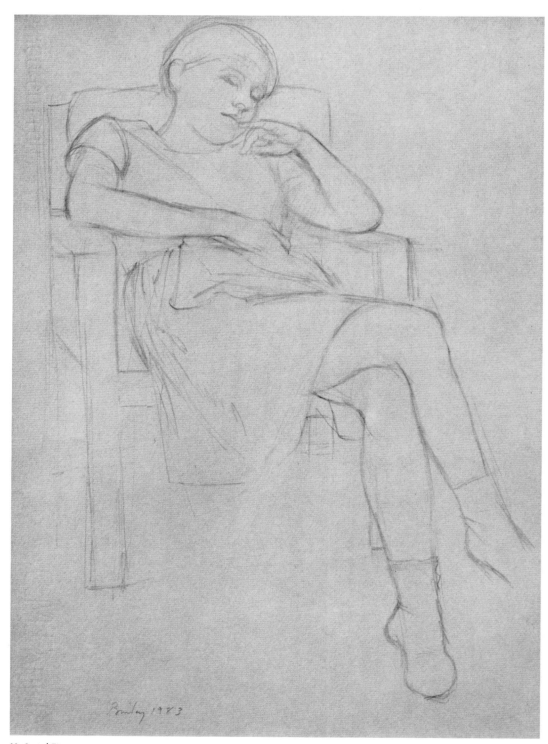

32. Seated Figure

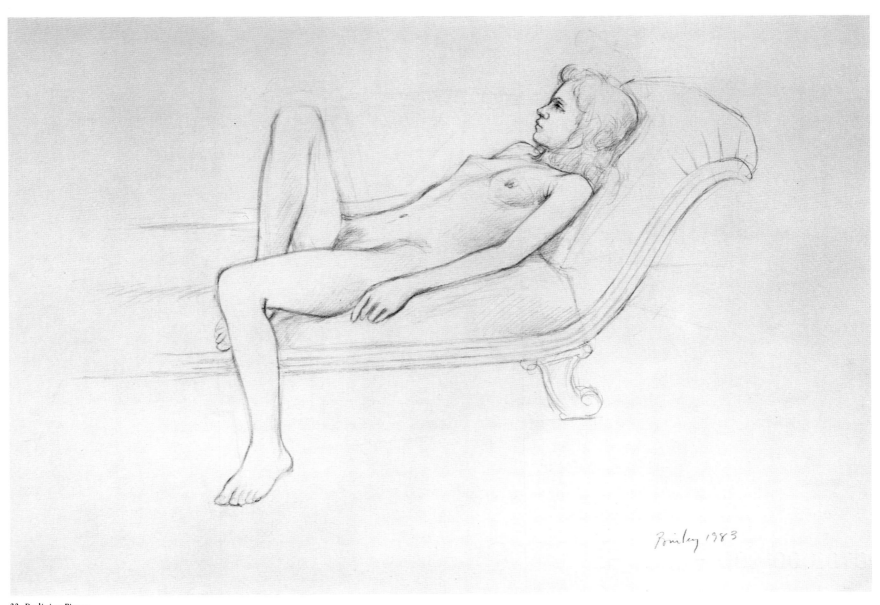

Bomley 1983

33. Reclining Figure

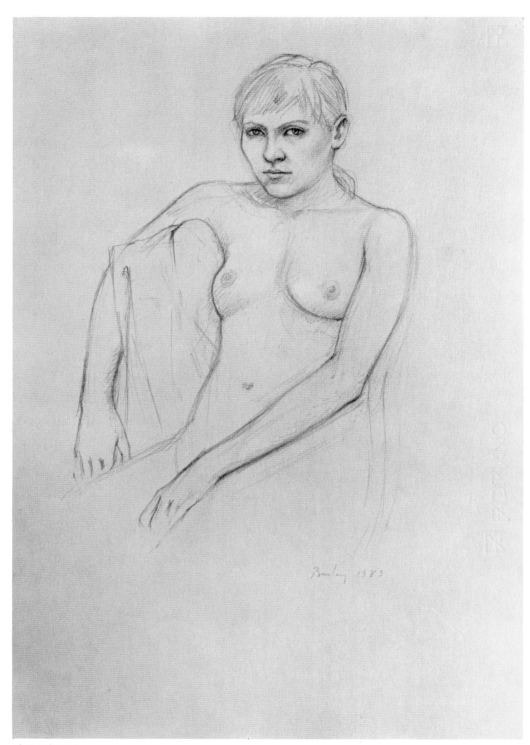

34. Seated Figure

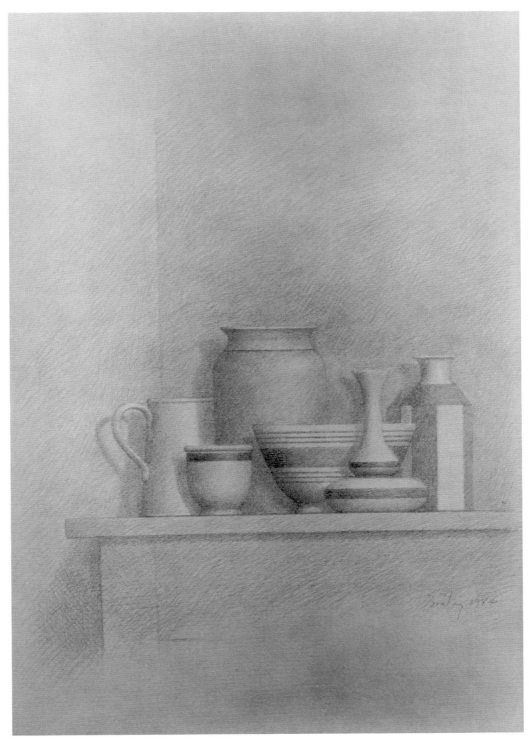

35. Still Life

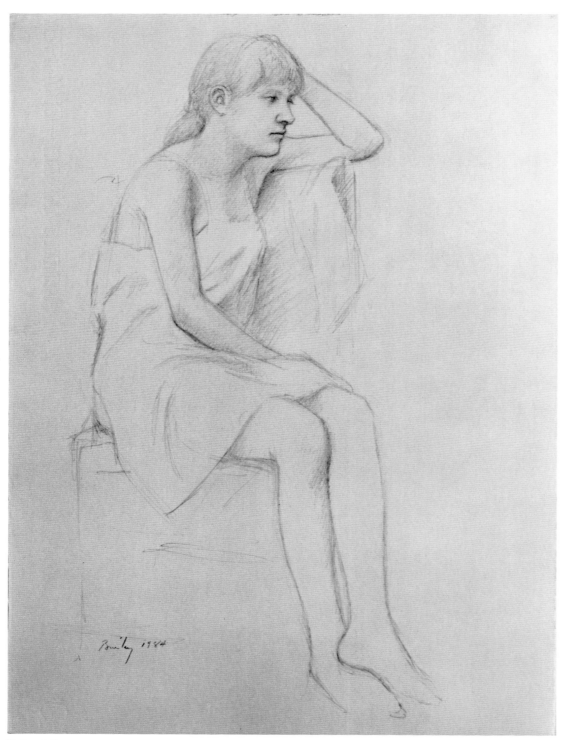

36. Seated Figure

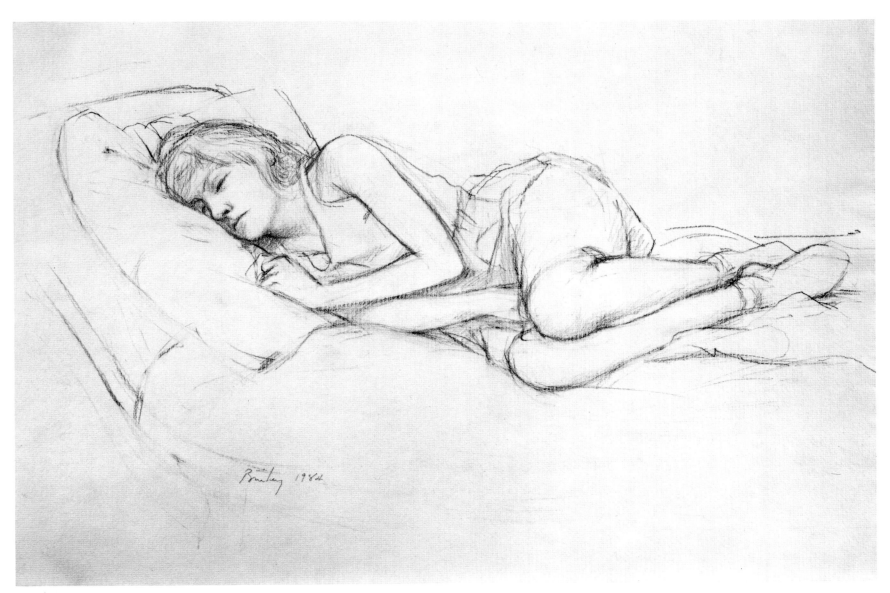

37. Reclining Figure

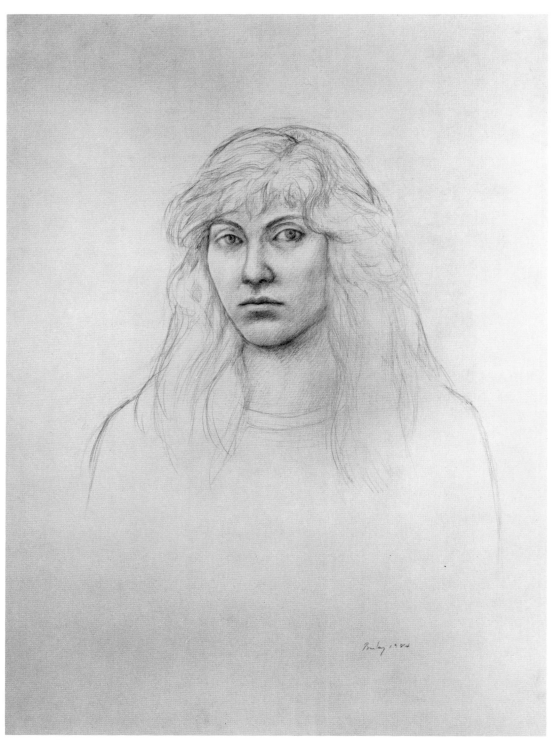

38. Portrait of C

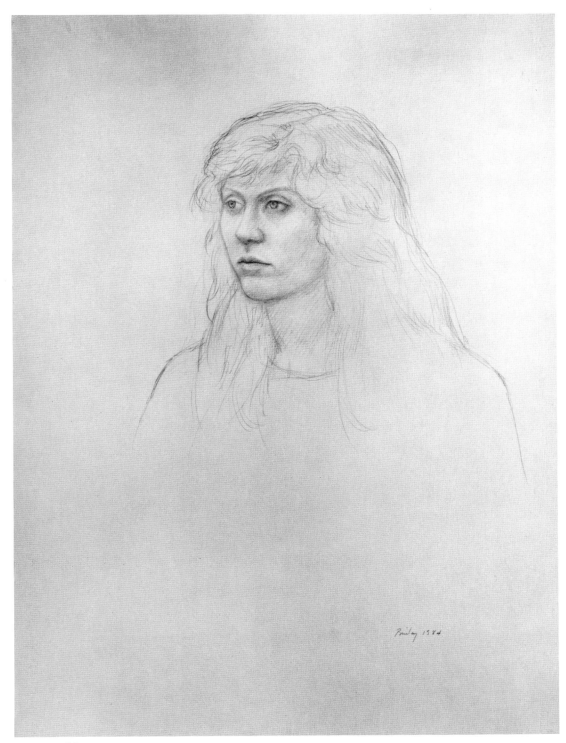

39. Portrait of C

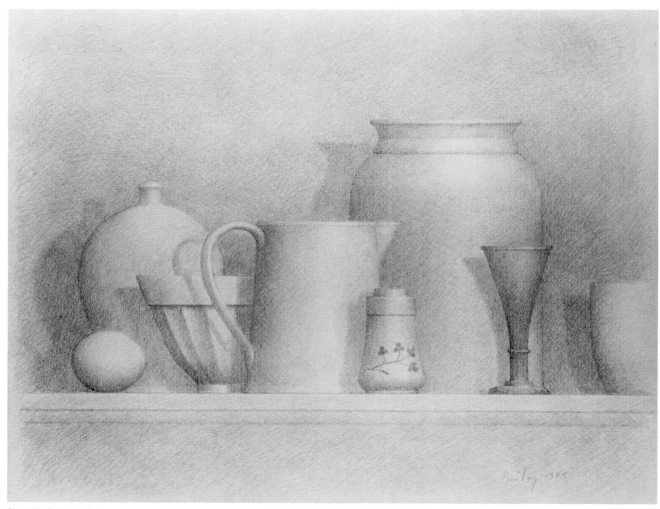

40. Still Life Via del Ocà

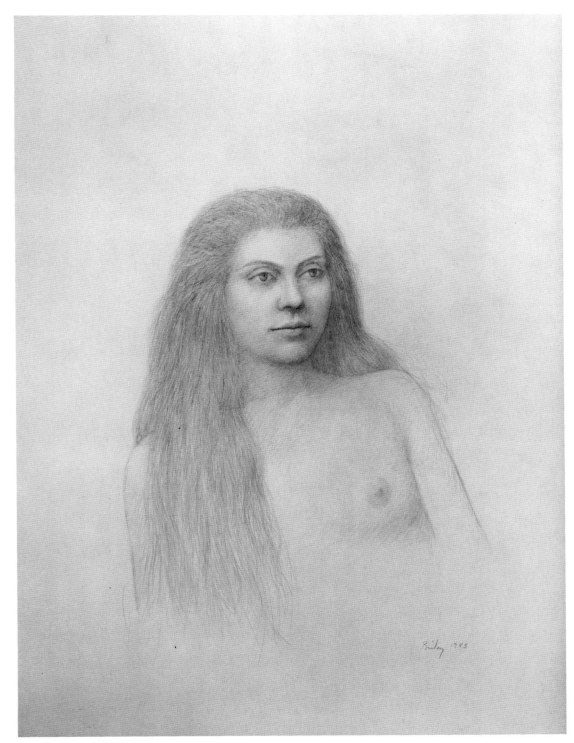

41. Girl with Long Hair

LIST OF PLATES

1. *Still Life with Eggs, Bowl and Vase*. 1971.
 Oil on canvas, 40 × 44″.
 Private Collection, Bedford, New York

2. *Still Life San Donato*. 1986.
 Pencil on paper, 19¼ × 16¾″.
 Courtesy of The Equitable Life Assurance Society of the U.S.

3. *Italian Profile*. 1963.
 Oil on canvas, 16 × 12″.
 Collection the artist

4. *N*. 1964.
 Oil on canvas, 48 × 72″.
 Whitney Museum of American Art, New York

5. *Table with Ochre Wall*. 1972.
 Oil on canvas, 47¾ × 53¾″.
 Yale University Art Gallery. Purchased with the aid of funds from the National Endowment for the Arts and the Susan Morse Matching Fund

6. *Migianella Still Life with Tureen*. 1973.
 Oil on canvas, 45 × 57½″.
 Kronos Collection

7. *Migianella Still Life with Pitcher*. 1974.
 Oil on canvas, 36 × 51″.
 Collection Estee Lauder, Inc.

8. *Girl in White Skirt*. 1977.
 Oil on canvas, 39¼ × 31¾″.
 Private Collection, New York

9. *Manhattan Still Life*. 1980.
 Oil on canvas, 40 × 50″.
 General Mills Art Collection, Minneapolis

10. *Portrait of S*. 1980.
 Oil on canvas, 50 × 40″.
 University of Virginia Art Museum, Charlottesville

11. *Still Life Città di Castello*. 1980.
 Oil on canvas, 35 × 46½″.
 Private Collection, New York

12. *Monte Migiana Still Life*. 1981.
 Oil on canvas, 54³⁄₁₆ × 60³⁄₁₆″.
 Pennsylvania Academy of the Fine Arts. Academy purchase with funds from the National Endowment for the Arts (Contemporary Arts Purchase Fund) and Bernice McHilhenny Wintersteen, the Women's Committee of the Pennsylvania Academy, Marion B. Stroud, Mrs. H. Gates Lloyd, and Theodore T. Newbold

13. *Mercatale Still Life*. 1981.
 Oil and wax on canvas, 30 × 40″.
 The Museum of Modern Art, Blanchette Rockefeller Fund, New York

14. *Still Life Monterchi*. 1981.
 Oil on canvas, 38 × 51″.
 Collection Mr. and Mrs. Alexander F. Milliken

15. *Still Life Pisa*. 1984.
 Oil on canvas, 50 × 60″.
 Collection Mr. and Mrs. Alan V. Tishman

16. *Still Life Torre*. 1984.
 Oil on canvas, 45¾ × 35¼″.
 Private Collection

17. *Still Life Genoa*. 1984.
 Oil on canvas, 51 × 76¾″.
 Collection Exxon Corporation

18. *Still Life Hotel Raphael*. 1985.
 Oil on canvas, 40 × 50″.
 Courtesy of The Equitable Life Assurance Society of the U.S.

19. *L*. 1986.
 Oil on canvas, 51 × 38″.
 Private Collection

20. *Still Life Nogna*. 1986.

Oil on canvas, 40 × 50".
Collection Mr. and Mrs. Richard C. Hedreen

21. *Still Life Noto*. 1986.
Oil on canvas, 40 × 50".
Collection Diane and David Goldsmith, California

22. *Head*. 1975.
Pencil on paper, 14¼ × 11".
Collection Mark Strand

23. *Portrait of Dee*. 1975.
Pencil on paper, 14¾ × 11".
Collection Mr. and Mrs. Robert J. Schoelkopf, Jr.

24. *Still Life*. 1977.
Pencil on paper. 13 × 21".
Collection Dr. Murray D. List

25. *Girl with Necklace*. 1977.
Pencil on paper, 11 × 14".
Private Collection, New York

26. *Head*. 1980.
Pencil on paper, 14 × 11".
Collection Dr. Eugene A. Solow

27. *Reclining Figure*. 1981.
Pencil on paper. 30 × 22".
Collection Mr. and Mrs. Stan Scholsohn

28. *Untitled Nude*. 1981.
Pencil on paper, 30 × 22".
Private Collection, New York

29. *Still Life Piazza Bologna*. 1982.
Pencil on paper, 22 × 15¾".
Private Collection, Boston

30. *Standing Figure*. 1983.
Sanguine on paper, 26 × 19¼".
Collection Betsy and Frank Goodyear

31. *Seated Figure*. 1983.
Pencil on paper, 15 × 11¼".

Collection Mr. and Mrs. Ronald W. Moore

32. *Seated Figure*. 1983.
Pencil on paper, 15 × 11⅛".
Collection Mr. and Mrs. Robert L. Freudenheim, Buffalo, New York

33. *Reclining Figure*. 1983.
Pencil on paper, 13⅝ × 19¾".
Collection Eileen and Carl Baird, Narbeth, Pennsylvania

34. *Seated Figure*. 1983.
Pencil on paper, 19¾ × 14".
Robert Schoelkopf Gallery, Ltd., New York

35. *Still Life*. 1984.
Pencil on buff paper, 19 × 13".
Collection Mr. and Mrs. Richard F. Kauders

36. *Seated Figure*. 1984.
Pencil on paper, 15 × 11".
Private Collection, Washington, D.C.

37. *Reclining Figure*. 1984.
Pencil on paper, 13¼ × 19".
Collection the artist

38. *Portrait of C*. 1984.
Pencil on paper, 30 × 22".
Private Collection, Washington, D.C.

39. *Portrait of C*. 1984.
Pencil on paper, 30 × 22".
Robert Schoelkopf Gallery, Ltd., New York

40. *Still Life Via del Ocà*. 1985.
Pencil on paper, 16½ × 19⅛".
Collection Jalane and Richard Davidson

41. *Girl with Long Hair*. 1985.
Pencil on paper, 30 × 22".
Private Collection

WILLIAM BAILEY

BIOGRAPHY

Born: November 17, 1930 Council Bluffs, Iowa
Residence: New Haven, Connecticut and near Perugia, Italy

EDUCATION

University of Kansas, School of Fine Arts, 1948–51
Yale University, School of Art, B.F.A. 1955
Yale University, School of Art, M.F.A. 1957

AWARDS

1955 Alice Kimball English Traveling Fellowship
1958 First Prize in Painting, Boston Arts Festival
1960 American Specialist Grant, travel in Southeast Asia
1965 Guggenheim Fellowship in Painting
1975 Ingram-Merrill Foundation Grant for Painting
1983–84 Visiting Artist, American Academy in Rome
1985 Yale Arts Medal for Distinguished Contribution in
 Painting
1986 Elected Member of The American Academy and Insti-
 tute of Arts and Letters

TEACHING

1957–62 School of Art, Yale University
1962–69 Indiana University
1969–79 Professor of Art, School of Art, Yale University
1974–75 Dean of the School of Art, Yale University
From 1979 Kingman Brewster Professor of Art, School of Art, Yale
 University

LIST OF EXHIBITIONS

ONE-MAN EXHIBITIONS

1956 Robert Hull Fleming Museum, University of Vermont,
 Burlington
1957 Kanegis Gallery, Boston
1958 Kanegis Gallery, Boston
1961 Kanegis Gallery, Boston
1963 Indiana University Art Museum, Indiana University,
 Bloomington
1967 Kansas City Art Institute, Kansas City, Missouri
1968 Robert Schoelkopf Gallery, New York
1969 Nasson College, Springvale, Maine
1971 Robert Schoelkopf Gallery, New York
1972 City University of New York, Queens College, Flushing
 Tyler School of Art, Temple University, Philadelphia
 University of Connecticut, Storrs

1973 Galleria il Fante di Spade, Rome
 Galleria Dei Lanzi, Milan, Italy
 Galleria La Parisina, Turin, Italy
1974 Robert Schoelkopf Gallery, New York
1975 Polk Museum, Lakeland, Florida. Exhibition traveled
 to Ft. Lauderdale, Florida
1976 Dart Gallery, Chicago
1978 Galerie Claude Bernard, Paris
1979 Fendrick Gallery, Washington, D.C.
 Robert Schoelkopf Gallery, New York
1980 Galleria d'Arte il Gabbiano, Rome
1982 Robert Schoelkopf Gallery, New York
1983 Meadows Gallery, Southern Methodist University, Dal-
 las, Texas
1984 The American Academy in Rome, Italy
1985 Galleria d'Arte il Gabbiano, Rome
1986 Robert Schoelkopf Gallery, New York

SELECTED GROUP EXHIBITIONS

1957 "Selection 1957," Institute of Contemporary Art, Boston

1959 "New Talent 1959," Art in America, New York

1960 "View of 1960," Institute of Contemporary Art, Boston

1961 "Contemporary American Painting and Sculpture," University of Illinois, Champaign-Urbana

1962 "Five New England Artists," Silvermine Guild Center for the Arts, New Canaan, Connecticut

1967 "Art on Paper," Weatherspoon Gallery, University of North Carolina, Greensboro

1968 "The Big Figure," Wilcox Gallery, Swarthmore College, Swarthmore, Pennsylvania

"Realism Now," Vassar College Art Gallery, Vassar College, Poughkeepsie, New York

1969 "Drawings U.S.A. 1968," St. Paul Art Center, St. Paul, Minnesota

1970 "Childe Hassam Purchase Exhibition," The American Academy and Institute of Arts and Letters, New York

"22 Realists," Whitney Museum of American Art, New York. Exhibition traveled to Norfolk Museum of Art, Norfolk, Virginia; Museum of Art of Ogunquit, Ogunquit, Maine

1971 "Childe Hassam Purchase Exhibition," The American Academy and Institute of Arts and Letters, New York

"Realist Painters," Florida State University, Tallahassee. Exhibition traveled to University of New Mexico, Albuquerque

1972 "Five Figurative Artists," Kansas City Art Institute, Kansas City, Missouri. Exhibition traveled to Weatherspoon Gallery, University of North Carolina, Greensboro; Butler Institute of American Art, Youngstown, Ohio

"Realism," organized by The American Federation of the Arts, Rhode Island School of Design, Providence, Rhode Island

1973 "Realist Revival," New York Cultural Center, New York

1974 "Living American Artists and the Figure," Pennsylvania State University, University Park

"Seven Realists," Yale University Art Gallery, New Haven, Connecticut

1975 "The Figure in Recent American Painting," St. John's University, Jamaica, New York

"Three Centuries of the American Nude," New York Cultural Center, New York

"William Bailey and Brice Marden: Recent Prints," Knoedler Graphics, New York

1976 "America the Third Century," Underwriters, Mobile Oil, The Corcoran Gallery of Art, Washington, D.C.

1977 "Biennale Internationale," Palazzo Strozzi, Florence

"William Bailey and Costantino Nivola," The American Academy in Rome

1978 "American Academy in Rome: Five Painters," Union Carbide Building, New York

"Salon de Mai," Paris

1979 "American Painting of the 60s and 70s. The Real, The Ideal, The Fantastic," Whitney Museum of American Art, New York

"Artists Choose: Figurative/Realist Art," Artist's Choice Museum, New York

"Drawings 1979," Landmark Gallery, New York

1980 "The Figurative Tradition," Whitney Museum of American Art, New York

"Still Life Today," Goddard-Riverside Community Center, New York

1981 "American Painting 1930–1980," Haus der Kunst, Munich, West Germany. Organized by the Whitney Museum of American Art, New York

"Contemporary American Realism Since 1960," Pennsylvania Academy of the Fine Arts, Philadelphia. Exhibition traveled to Oakland Museum, California; Virginia Museum of Fine Arts, Richmond. Exhibition traveled abroad to Portugal, Germany, and Holland 1982–83

"Contemporary Artists," The Cleveland Museum of Art, Ohio

"The Image in American Painting and Sculpture 1950–1980," Akron Art Museum, Ohio

"Joseph Albers: His Art and Influence," Montclair Art Museum, New Jersey

"Mantegna to Rauschenberg: Six Centuries of Prints," Babcock Gallery, New York

"Real, Really Real and Super Real," San Antonio Museum of Art, Texas. Exhibition traveled to Tucson Museum of Art, Arizona; Museum of Art, Carnegie Institute, Pittsburgh

"20 Artists: Yale School of Art 1950–1970," Yale University Art Gallery, New Haven

"The Whitney Biennial," Whitney Museum of American Art, New York

1982 "Paintings and Sculpture by Candidates for Art Awards," The American Academy and Institute of Arts and Letters, New York

"Perspectives on Contemporary American Realism: Works of Art on Paper from the Collection of Jalane and Richard Davidson," Pennsylvania Academy of the Fine Arts, Philadelphia. Exhibition traveled to The Art Institute of Chicago

"A Private Vision: Contemporary Art from the Graham Gund Collection," Museum of Fine Arts, Boston

1983 "American Still Life: 1945–1983," Contemporary Arts Museum, Houston, Texas. Exhibition traveled to the Albright-Knox Art Gallery, Buffalo, New York; Columbus Museum of Art, Ohio; Neuberger Museum, State University of New York at Purchase; Portland Art Museum, Oregon

"A Heritage Renewed: Representational Drawing Today," University Art Museum, University of California, Santa Barbara. Exhibition traveled to Oklahoma Art Center, Oklahoma; Elvehjem Museum of Art, University of Wisconsin, Madison; Colorado Springs Fine Arts Center, Colorado

"Connecticut Painters: 7 Plus 7 Plus 7," Wadsworth Atheneum, Hartford, Connecticut

"Live from Connecticut," Whitney Museum of Art, Stamford, Connecticut

1984 "Invitational Drawing Exhibition," Art and Architecture Gallery, University of Tennessee, Knoxville

"New York Realism: Small Works and Preliminary Sketches," College of the Mainland Art Gallery, Texas City, Texas

"Print Acquisitions 1974–1984," Whitney Museum of American Art, New York

"Recent American Still Life Painting," Robert Schoelkopf Gallery, New York

1985 "American Art Today: Still Life," Florida International University, Miami

"A Decade of American Realism: 1975–1985," Wichita Art Museum, Kansas

"Focus on Realism: Selections from the Collection of

Glenn C. Janss, Boise Gallery of Art, Idaho
"Visiting Artists," Kansas City Art Institute, Kansas City, Missouri

1985–86 "American Realism: Twentieth Century Drawings and Watercolors from the Collection of Glenn C. Janss," San Francisco Museum of Modern Art, California. Exhibition traveled to DeCordova and Dana Museum and Park, Lincoln, Massachusetts; Huntington Art Gallery, University of Texas, Austin; Mary and Leigh Block Gallery, Northwestern University, Evanston, Illinois; Museum of Art, Williams College, Williamstown, Massachusetts; Akron Art Museum, Ohio; Madison Art Center, Wisconsin

1986 "American Drawings: Realism/Idealism," Jane Haslem Gallery, Washington, D.C.

"Exhibition of Work by Newly Elected Members and Recipients of Awards," The American Academy and Institute of Arts and Letters, New York

1986–87 "The Homecoming," Iowa Art Council and the Gallery of Art, University of Northern Iowa, Cedar Falls

PUBLIC COLLECTIONS

Arkansas Arts Center, Little Rock
The Art Institute of Chicago, Illinois
Chemical Bank, New York
Des Moines Art Center, Iowa
Equitable Real Estate Group, Inc., New York
Estee Lauder, Inc., New York
Exxon Corporation, New York
General Mills Corporation, Minneapolis, Minnesota
The Hirshhorn Museum and Sculpture Garden, Smithsonian Institution, Washington, D.C.

Indiana University Art Museum, Bloomington
J. B. Speed Museum, Louisville, Kentucky
J. Henry Schroder Banking Corporation, New York
Kresge Art Museum, Michigan State University, East Lansing
Lehman Brothers Shearson American Express, New York
Montclair Art Museum, New Jersey
Museum of Art, Duke University, Durham, North Carolina
Museum of Art of Ogunquit, Ogunquit, Maine
The Museum of Modern Art, New York
National Museum of American Art, Smithsonian Institution, Washington, D.C.
The New York Times, New York
Ing. C. Olivetti & C., S. p. A., Ivrea, Italy
Pennsylvania Academy of the Fine Arts, Philadelphia
Pennsylvania State University, University Park
Rose Art Museum, Brandeis University, Waltham, Massachusetts
St. Louis Art Museum, Missouri
Sheldon Swope Art Gallery, Terre Haute, Indiana
Stadtisches Suermondt-Ludwig-Museum, Aachen, West Germany
State University of New York at Cortland
University of Kentucky, Lexington
University of Massachusetts, Amherst
University of New Mexico, Albuquerque
University of Virginia Art Museum, Charlottesville
Weatherspoon Art Gallery, University of North Carolina, Greensboro
Whitney Museum of American Art, New York
Wichita Art Museum, Kansas
William Benton Museum of Art, University of Connecticut, Storrs
Yale University Art Gallery, New Haven

SELECTED BIBLIOGRAPHY

EXHIBITION CATALOGUES

Selection 1957. Text by Thomas M. Messer. Boston: Institute of Contemporary Art, 1957

Contemporary American Painting and Sculpture. Text by Allen S. Weller. Urbana, Illinois: Krannert Art Museum, 1961

Graphics 1963. Preface by Edward W. Rannells. Lexington, Kentucky: University of Kentucky Art Gallery, 1963

Realism Now. Text by Linda Nochlin. Poughkeepsie, New York: Vassar College Art Gallery, 1968

22 Realists. Text by James K. Monte. New York: Whitney Museum of American Art, 1970

William Bailey. Essay by Ugheta Fitzgerald ("Alcune Note sulla Pittura di William Bailey"). Rome: Galleria il Fante di Spade, 1973

American Poster 1945–75. Text by Margaret Cogswell. Washington, D.C.: Corcoran Gallery of Art, 1975

Seven Realists. Preface by Alan Shestack, essay on William Bailey by A[nne] M[cAuley]. New Haven, Connecticut: Yale University Art Gallery, 1974

Connecticut Painting, Drawing and Sculpture 78. Text by Virginia Mann Haggin. New Haven, Connecticut: University of Bridgeport, 1978

William Bailey: Peintures. Essays by Hilton Kramer and Jean Paget. Paris: Galerie Claude Bernard, 1978

William Bailey: Recent Paintings. Introduction by Mark Strand. New York: Robert Schoelkopf Gallery, 1979

American Portrait Drawings. Text by Marvin Sadek and Harold Francis Pfister. Washington, D.C.: National Portrait Gallery, Smithsonian Institution, 1980

The Figurative Tradition and the Whitney Museum of American Art. Texts by Patricia Hills and Roberta K. Tarbell. New York: Whitney Museum of American Art, 1980

Realism—Photo Realism. Text by John Arthur. Tulsa, Oklahoma: Philbrook Art Center, 1980

William Bailey: New Work. Texts by Alberto Moravia ("Nelle Realtà del Vivere Quotidiano") and Mark Strand ("L'Opera Ricente"). Rome: Galleria d'Arte il Gabbiano, 1980

Collaboration: Artists and Architects. Editor: Barbaralee Diamonstein. New York: Architectural League of New York, 1981

Contemporary Artists. Text by Tom E. Hinson. Cleveland, Ohio: The Cleveland Museum of Art, 1981

The Image in American Painting and Sculpture 1950–1980. Essay by Carolyn Kinder Carr. Akron, Ohio: Akron Art Museum, 1981

Joseph Albers: His Art and Influence. Text by Nicholas Fox Weber. Montclair, New Jersey: The Montclair Art Museum, 1981

Real, Really Real and Super Real. Essay by Alvin Martin. San Antonio, Texas: San Antonio Museum of Art, 1981

The Whitney Biennial Exhibition 1981. Texts by Tom Armstrong, John G. Hanhardt, Barbara Haskell, Richard Marshall, Patterson Sims. New York: Whitney Museum of American Art, 1981

Ameriknische Malerei. Text by Tom Armstrong. Munich, West Germany: Haus der Kunst, 1982

Perspectives on Contemporary American Realism: Works of Art on Paper from the Collection of Jalane and Richard Davidson. Text by Frank Goodyear, Jr. Philadelphia: Pennsylvania Academy of the Fine Arts, 1982

William Bailey: Recent Paintings. Introduction by John Hollander. New York: Robert Schoelkopf Gallery, 1982

American Still Life: 1945–83. Text by Linda L. Cathcart. New York: Harper & Row in conjunction with the Contemporary Arts Museum, Houston, Texas, 1983

A Heritage Renewed. Text by Phyllis Plous. Santa Barbara, California: University Art Museum, 1983

L'immagine e il suo Doppio. Text by Floriano De Santi. Milan: Palazzo Bagatti Valsecchi, 1984

Invitational Drawing Exhibition. Text by Sam Yates. Knoxville: University of Tennessee, 1984

Parasol and Simca: Two Presses/Two Processes. Text by Lizbeth Marano. Lewisburg, Pennsylvania: Center Gallery of Bucknell University, 1984

American Art Today: Still Life. Text by Carter Ratcliff. Miami: Florida International University, 1985

American Realism: Twentieth Century Drawings and Watercolors from the Collection of Glenn C. Janns. Text by Alvin Martin. San Francisco Museum of Modern Art, 1985

William Bailey: Recent Paintings. Introduction by Andrew Forge. New York: Robert Schoelkopf Gallery, 1986

BOOKS, PERIODICAL AND NEWSPAPER ARTICLES

Alexandre, Phil. "William Bailey: The State of the Artist." *The Kenyon Journal,* Gambier, Ohio. May 1986, pp. 6–11

Apuleo, Vito. "William Bailey: Astratta Classicita." *Il Messaggero* (Rome), March 19, 1985

Arthur, John. *Realist Drawings and Watercolors.* Boston: New York Graphic Society, 1980

Artner, Alan G. "Art." *Chicago Tribune,* April 3, 1983, arts and books section, pp. 16–17

Bass, Ruth. "The Illusion of Reality." *Art News,* vol. 80, no. 10 (Dec. 1981), pp. 78–81

Becker, Ludwig. *Neue Galerie der Stadt Aachen: Der Bestand 72* [catalogue of the collection]. Aachen, West Germany: the museum, 1972

Bernardi, Marziano. "La Pittura e i Segni." *La Stampa* (Turin), Jan. 10, 1974, p. 7

B[rown], G[ordon]. "In the Galleries." *Arts Magazine,* vol. 42, no. 2 (Nov. 1971), p. 72

C[ampbell], L[awrence]. "Reviews and Previews." *Art News,* vol. 70, no. 7, (Nov. 1971), p. 12

Clair, Jean. "Il Ritorno della Natura Morta." *Casa Vogue,* Sept. 1981, pp. 352–55

Davis, Douglas. "Mixed Marriages of Art." *Newsweek,* vol. 97, no. 11 (March 16, 1981), p. 71

Diwan, Fiona. "Il Momento dei Nuovi Eclettici: I Tritatutto." *Panorama* (Milano), Sept. 6, 1982, pp. 82–86

Dragoni, Angelo. "Mostre d'Arte." *Stampa Sera* (Turin), Jan. 11, 1974

Evett, Kenneth. "Academic Question." *The New Republic,* vol. 172, no. 7 (Feb. 15, 1975), pp. 30–31

Filler, Martin. "Qu'est-ce qu'est Américain dans l'Architecture Américain?" *Paris Vogue,* April 19, 1982, p. 222–23

Forgey, Benjamin. "Painting the Familiar." *Washington Star* (Wash., D.C.), April 15, 1979

French-Frazier, Nina. "William Bailey." *Arts Magazine,* vol. 53, no. 8 (April 1979), p. 9

Gibson, Eric. "New York." *Art International,* vol. 22, no. 10 (March 1979), p. 49

———. "American Still Life." *The New Criterion,* vol. 3, no. 2 (Oct. 1984), pp. 70–75

Glueck, Grace. "Previews." *Art in America,* vol. 59 (March 1971), p. 45

————. "Art: American Still Life with the Accent on Life." *The New York Times,* July 20, 1984

Goodyear, Jr., Frank H. *Contemporary American Realism Since 1960.* Boston: New York Graphic Society in association with the Pennsylvania Academy of the Fine Arts, 1981

————. "American Realism Since 1960: Beyond the Perfect Green Pea." *Portfolio Magazine,* Nov.–Dec. 1981, p. 72

Gruen, John. "William Bailey: Mystery and Mastery." *Art News,* vol. 78, no. 9 (Nov. 1979), pp. 140–43, 145

G[uiliano], C[harles]. "In the Galleries." *Arts Magazine,* vol. 42, no. 5 (March 1968), p. 60

Haim, Nadine. *Peintres aux Fourneaux.* Paris: Flammarion, 1985

Henry, Gerrit. "A Preference for the Perfect." *Art News,* vol. 78, no. 4 (April 1979), p. 145

————. "Recent American Still Life Painting." *Art News,* vol. 85, no. 3 (March 1985), p. 144

————. "William Bailey at Schoelkopf." *Art in America,* vol. 75, no. 3 (March 1987), p. 140

Hollander, John. "Artist's Dialogue: William Bailey, An Extreme and Abstract Clarity." *Architectural Digest,* Dec. 1986, pp. 44, 48–50

Hughes, Robert. "The Realist as Corn God." *Time,* Jan. 31, 1972, pp. 50–55

Jürgen-Fischer, Klaus. "Neuer Naturalismus." *Das Kunstwerk,* vol. 23, no. 5–6 (Feb.–March 1970), pp. 3–34

Kahmen, Volker. *Erotic Art Today.* Greenwich, Connecticut: New York Graphic Society, 1972

Kohen, Helen L. "Still Life Paintings that will Take Your Breath Away." *Miami Herald,* Jan. 20, 1985

Kramer, Hilton. "Form, Fantasy, and the Nude." *The New York Times,* Feb. 11, 1968, p. D25

————. "Dear Reader, Worry No More." *The New York Times,* Feb. 15, 1970, sect. 2, p. 23

————. "William Bailey and the Artifice of Realism." *The New York Times,* Oct. 31, 1971, sect. 2, p. 21

————. "Extreme Cross Purposes." *The New York Times,* Dec. 10, 1972, sect. 2, p. 27

————. *The Age of the Avant-Garde: An Art Chronicle of 1956–1972.* New York: Farrar, Straus and Giroux, 1973

————. "Realism: The Painting is Fiction Enough." *The New York Times,* April 28, 1974, sect. 2, p. 19

————. "Art: William Bailey Still Lifes." *The New York Times,* Oct. 26, 1974, p. 25

————. "Art: Stuart Davis and William Bailey." *The New York Times,* Jan. 12, 1979, p. C14

————. "Art View: The Return of the Realists and a New Battle Shaping Up." *The New York Times,* Oct. 25, 1981, sect. 2, p. 1 + 35

Kultermann, Udo. *The New Painting.* Rev. ed. Boulder, Colorado: Westview Press, 1977

Kutner, Janet. "Quiet Authority." *Dallas Morning News,* March 23, 1983, sect. C, pp. 1–3

Laderman, Gabriel. "Unconventional Realists." *Artforum,* vol. 6, no. 3 (Nov. 1967), pp. 42–46

Lanes, Jerold. "Review." *Burlington Magazine,* March 1968, p. 170

————. "Problems of Representation: Are We Asking the Right Questions?" *Artforum,* Jan. 1972, pp. 60–62

Lipman, Jean, ed. "New Talent 1959." *Art in America,* vol. 47, no. 1 (Spring 1959), p. 48

Lubell, Ellen. "An Air of Serenity." *Soho Weekly News,* Jan. 18, 1979

"Maestri del Silenzio." *Arte* (Milano), April 1985

Marvel, Bill. "More Credible Than Realistic." *Dallas Times Herald,* March 9, 1983

Mazars, Pierre. "Silence! Peinture." *Le Figaro* (Paris), April 14, 1978, p. 22

Micacchi, Dario. "Realismo Tradizionale nelle Opere di William Bailey." *L'Unità* (Rome), Feb. 24, 1973

Morosini, Diulio. "Bailey e il Realismo Classico." *Paese Sera* (Rome), Feb. 17, 1973, p. 10

Navrozov, Andrei. "William Bailey." *Art and Antiques,* Oct. 1986, pp. 57–59

Nemser, Cindy. "Representational Painting in 1971: A New Synthesis." *Arts Magazine,* vol. 46 (Dec. 1971), pp. 41–46

Oresman, Janice C. "Still Life Today." *Arts Magazine,* vol. 57 (Dec. 1982), pp. 111–15

Ouvaroff, I. E. "Quartetto Tacet." *The Yale Literary Magazine,* vol. 149, no. 1 (1981), pp. 8–13

Perl, Jed. "William Bailey's Poetic Realism." *Columbia Daily Spectator,* Nov. 5, 1971, p. 4

——————. "The Life of the Object: Still Life Painting Today." *Arts Magazine,* vol. 52 (Dec. 1977), pp. 27–28

P[errault], J[ohn]. "Reviews and Previews." *Art News,* vol. 67, no. 2 (April 1968), p. 9

Plazi, Giles. "William Bailey." *Quotidien Paris,* March 28, 1978, p. 18

Richard, Paul. "Clean, Fine, and Moving: The Still Life before the Storm." *Washington Post,* April 14, 1979

Russell, John. "Recent Paintings by William Bailey." *The New York Times,* April 23, 1982, p. C22

——————. "Art: William Bailey." *The New York Times,* Nov. 28, 1986, p. C22

Sager, Peter. "Neue Formen des Realismus." Cologne: Verlag M. DuMont Schauberg, 1973

Schjeldahl, Peter. "Realism—A Retreat to the Fundamentals?" *The New York Times,* Dec. 24, 1972, sect. 2, p. 25

Smith, Roberta. "Tempus Fidget." *Village Voice,* April 20, 1982, p. 89

Soavi, Giorgio. "Figure." *Epoca* (Rome), May 4, 1984, p. 98

Stevens, Mark. "Art Imitates Life: The Revival of Realism." *Newsweek,* vol. 99, no. 23 (June 7, 1982), pp. 64–70 [cover story]

Strand, Mark, ed. *Art of the Real: Nine American Figurative Painters.* Foreword by Robert Hughes. New York: Clarkson N. Potter, Inc., 1983

Tillim, Sidney. "The Reception of Figurative Art: Notes on a General Misunderstanding." *Artforum,* vol. 7 (Feb. 1969), pp. 30–33

Trombadori, Antonello. "Nature Morte e Risuscitate." *Europeo,* Feb. 9, 1981, p. 70

Trucchi, Lorenzo. "Bailey al Fante di Spade." *Momento Sera* (Rome), Feb. 16, 1973

"Weg von der Weihnachtsausstellung: *Spiegel*-Gespräch mit dem Dokumenta-Generalsekretär Harald Szeemann." *Der Spiegel,* April 12, 1971, p. 166

White, Edmund. "Realism." *Saturday Review of the Arts,* vol. 1, no. 2 (Feb. 1973), p. 57

BOOKS ILLUSTRATED

Eighty Poems of Antonio Machado. Illustrations by William Bailey. New York: Las Americas, 1958

A Lost Lady, Willa Cather. Illustrations by William Bailey. New York: The Limited Editions Club, 1983

PHOTOGRAPH CREDITS

All photography by eeva inkeri, with the exception of
the following, listed by plate numbers: Geri T. Mancini, 5;
Joseph Szaszfai, 25.